AUSTRALASIAN NATURE PHOTOGRAPHY

ANZANG EIGHTH COLLECTION

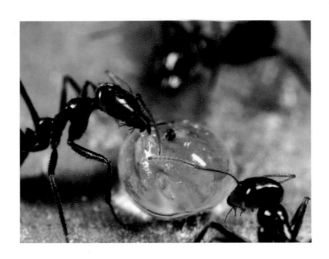

SOUTH AUSTRALIAN MUSEUM

Government
of South Australia

CSIRO
PUBLISHING

© South Australian Museum 2011

All rights reserved. Except under the conditions described in the Australian Copyright Act 1968 and subsequent amendments, no part of this publication may be reproduced, stored in a retrieval system or transmitted in any form or by any means, electronic, mechanical, photocopying, recording, duplicating or otherwise, without the prior permission of the copyright owner. Contact **CSIRO** PUBLISHING for all permission requests.

ANZANG Nature Photography
South Australian Museum
North Terrace
Adelaide, South Australia 5000
Australia

Telephone: 61 (0)8 8207 7426
Fax: 61 (0)8 8203 9805
Email: anzang@samuseum.sa.gov.au
Website: www.anzangnature.com

Published by
CSIRO PUBLISHING
150 Oxford Street (PO Box 1139)
Collingwood VIC 3066
Australia

Telephone: +61 3 9662 7666
Local call: 1300 788 000 (Australia only)
Fax: +61 3 9662 7555
Email: publishing.sales@csiro.au
Web site: www.publish.csiro.au

Front cover: Grey-headed Flying Fox drinking behaviour, Ofer Levy, New South Wales

Cover, text design and typesetting by James Kelly
Printed in China by 1010 Printing International Ltd

CSIRO PUBLISHING publishes and distributes scientific, technical and health science books, magazines and journals from Australia to a worldwide audience and conducts these activities autonomously from the research activities of the Commonwealth Scientific and Industrial Research Organisation (CSIRO). The views expressed in this publication are those of the author(s) and do not necessarily represent those of, and should not be attributed to, the publisher or CSIRO.

CONTENTS

SPONSORS

The South Australian Museum would like to thank our sponsors, who in 2011 have so generously supported this eighth cycle of competition and exhibition.

Mrs Alison Huber and Dr Stuart Miller, in memory of their parents, Dr Robert and Mrs Clarice Miller, both late of Waikerie, South Australia

2011 Competition Judges

Raoul Slater

David Hugh Evans

Glenn Ehmke

ACKNOWLEDGEMENTS

ANZANG Nature Photography is an annual highlight on the South Australian Museum's calendar, but does not happen without considerable work behind the scenes.

I would like to thank the following people for their assistance in making this competition and its accompanying exhibition possible:

- The photographers who entered this year's competition; our judges for selecting the finalists and award winners; and our sponsors for supporting us.

- The museum team of Mark Judd, Anah Guy and Emma-Lee Thomson for their administrative assistance for the competition and exhibition; Cameron Midson for designing the exhibition and Greg Parnell for hanging it; Jo Mason for editing the text; and Crispin Savage and Angie Hua for their assistance in promoting the competition and exhibition.

Tim Gilchrist
Coordinator, ANZANG Nature Photography

ANZANG was founded by Perth surgeon Dr Stuart Miller in 2003. He gifted the program to the South Australian Museum in 2009.

Australia, New Zealand, Antarctica and New Guinea

INTRODUCTION

Now in its eighth year, the annual ANZANG Nature Photography competition continues to mature, this year accepting more than 1600 images, each with a unique perspective on the natural world.

With the lens focussed on our local area, ANZANG invites photographers of any age, nationality or experience to submit their photographs taken in Australia, New Zealand, Antarctica and the New Guinea region. It serves to highlight and celebrate the region's unique biodiversity.

Our competition judges have the daunting duty of selecting the best photographs for inclusion in the ANZANG Nature Photography exhibition and this book, *Australasian Nature Photography: ANZANG Eighth Collection*.

I offer my congratulations to all photographers involved. Only a small proportion of the images can be exhibited; not being included is not a reflection on the photographer's ability, but rather an indication of the wealth of talented photographers working in the ANZANG region. So much talent makes this a difficult competition to judge and I thank our judges for their efforts.

I hope that all photographers and people who love nature will enjoy this collection of *Australasian Nature Photography*.

Prof Suzanne Miller
Director
South Australian Museum

ANZANG NATURE PHOTOGRAPHER OF THE YEAR – 2011
OVERALL WINNER

The overall winner of the competition is the photographer of the image judged best of all the images entered. Ofer Levy of New South Wales is this year's winner.

Judges, when making their selection, considered the photographic technique and the aesthetic, artistic and unique qualities of all images.

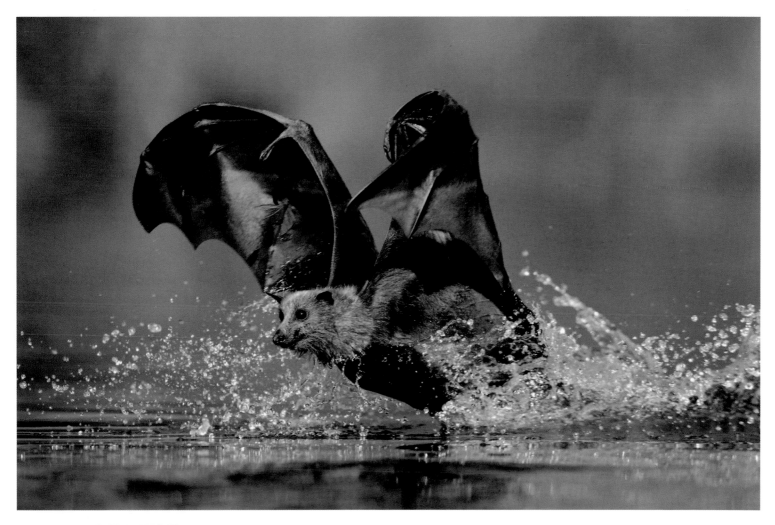

ANZANG 2011 – OVERALL WINNER
Grey-headed Flying Fox drinking behaviour
Ofer Levy, New South Wales

Grey-headed Flying Foxes drink in a unique way. They swoop low, skimming the water with their belly. They then lick the wet fur as they fly and continue licking when perched nearby. This behaviour usually occurs at dusk and night, but when the temperature reaches 35 degrees and above they will drink during the day. In order to get this image I stood in chest-deep water with the camera and lens mounted on a tripod.

Parramatta Park, New South Wales

■ Canon 1D MkIV, Canon 600mm f/4L IS lens, 1/3200, f5.6, ISO 1000

'A stunning action shot – technically perfect, with great light and fantastic depth of field.'
JUDGES' COMMENT

ANZANG NATURE PHOTOGRAPHER
OF THE YEAR – 2011
PORTFOLIO PRIZE

The portfolio prize is awarded to the photographer who enters
the best portfolio of six or more entries.

Alan Kwok of New South Wales is the winner of this year's prize.

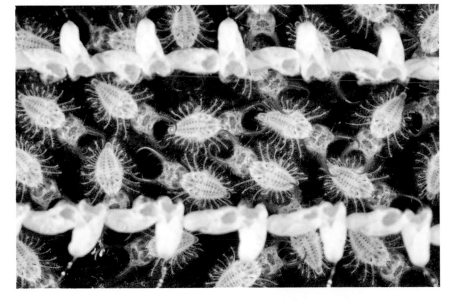

Clockwise from top left:
A sticky drop, A sticky end, Any port in a storm,
Nature's Pacman: a slater's defence, As snug as
a Jumping Spider, Lacewing larvae.

*'A creative, thoughtful and arty collection
of images that works with the diversity
within the world of small creatures.'*
JUDGES' COMMENT

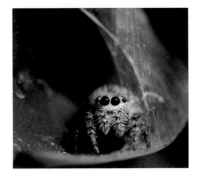

ANIMAL BEHAVIOUR

The subject or subjects must be engaged in natural activity.

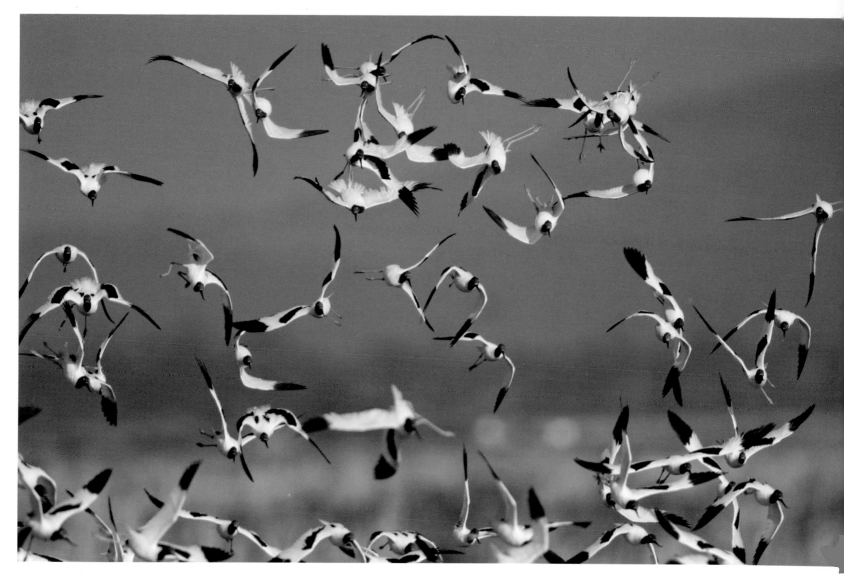

ANIMAL BEHAVIOUR – WINNER

Organised chaos

Dean Ingwersen, Victoria

While searching for a different species, I noticed a car coming towards this group of roosting Avocets. Knowing that the birds would flush, I positioned myself in the hope they would fly towards me. Seconds later I had this image, capturing the apparent chaos inside a wheeling flock of shorebirds.

Western Treatment Plant, Victoria

■ Canon 20D, 500mm f/4L IS lens, 1.4x TC, 1/2000, f5.6, ISO 200

'The chaos of the moment prompts the viewer to look into the image and observe the behaviour of individual birds.'
JUDGES' COMMENT

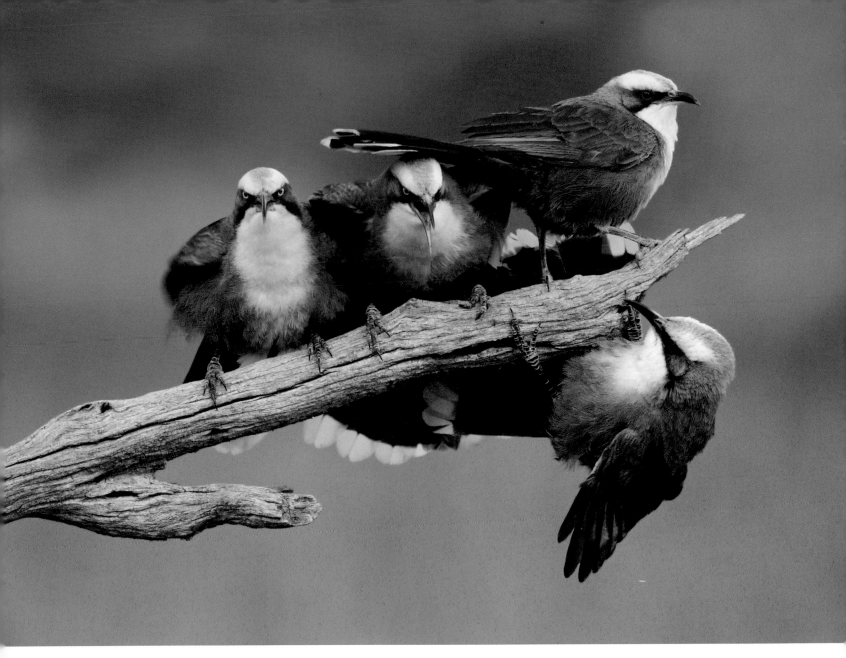

ANIMAL BEHAVIOUR – RUNNER-UP
Grey-crowned Babblers playing
Chris Tzaros, Victoria

These birds are renowned for their comical behaviour, and I was indeed fortunate to capture some of their antics while photographing this small party.

Lurg, Victoria

■ Canon 30D, 500mm f/4L IS lens, 1/160, f7.1, ISO 250

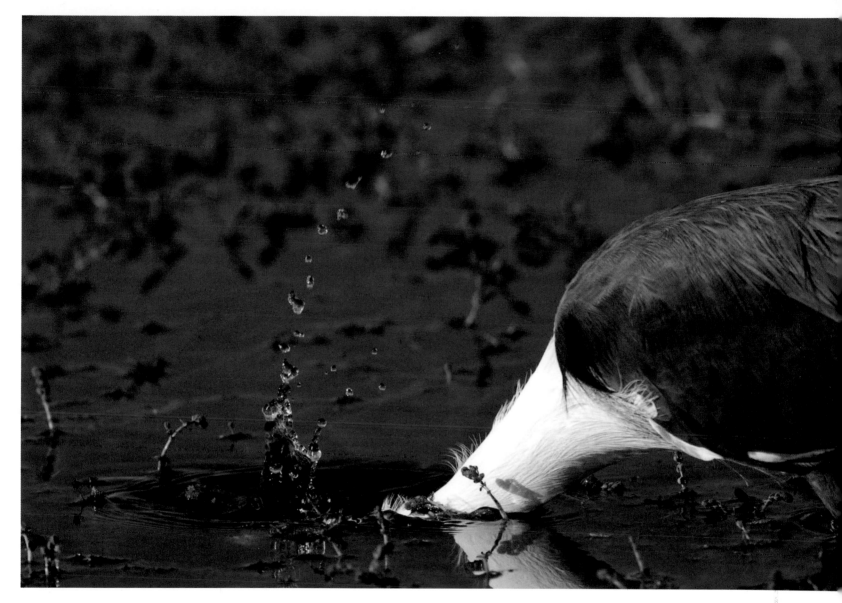

ANIMAL BEHAVIOUR

White-faced Heron

Arnold Faulks, New South Wales

The solitude of an early spring evening is punctuated by the sudden flash of a White-faced Heron disturbing the mirror-like surface of the inland billabong. As in all special moments of nature photography, time stands still while a crescent-shaped spray of water arches gracefully above, blessing both the heron and its unsuspecting prey.

Bowra Station, Queensland

■ Canon 40D, EF 300mm f/4L IS lens, 1/1600, f6.3, ISO 320

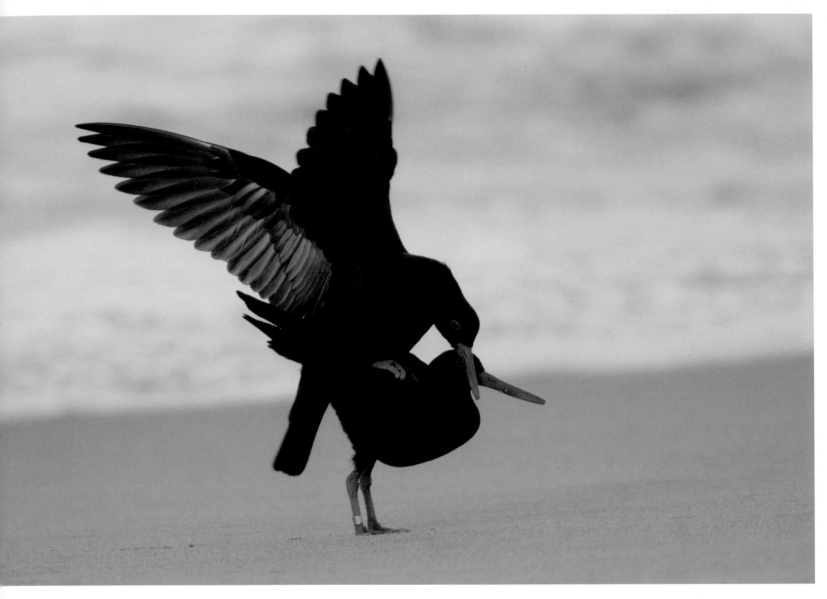

ANIMAL BEHAVIOUR

Sooty Oystercatchers mating

David Stowe, New South Wales

My target for the afternoon had been photographing Hooded Plovers. As the sun went down I left them alone and was about to leave, when I noticed this pair of Sooty Oystercatchers close by. I was amazed and thrilled to see and be able to capture this brief mating sequence while there was still enough light.

Saltwater Creek, Ben Boyd National Park, New South Wales

■ Canon 1D MkIII, 500mm f/4L IS lens, 1.4x TC, 1/640, f5.6, ISO 640

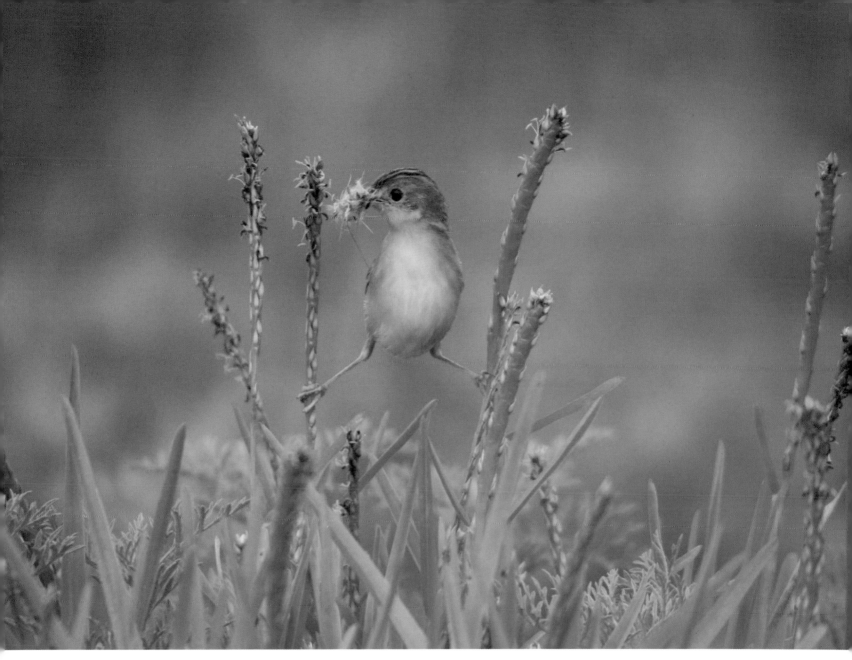

ANIMAL BEHAVIOUR

Golden-headed Cisticola

Allen Friis, New South Wales

I saw this tiny bird with a beak full of nesting materials while sitting in my vehicle having a cold drink.
It landed close, and there was a mad scramble to grab my camera and compose a shot. I was willing
it to stay on the grass stems, and I managed a nice sequence of photos.

Ash Island, Newcastle, New South Wales

■ Canon 40D, Sigma 150–500mm IS lens, 1/800, f6.3, ISO 400

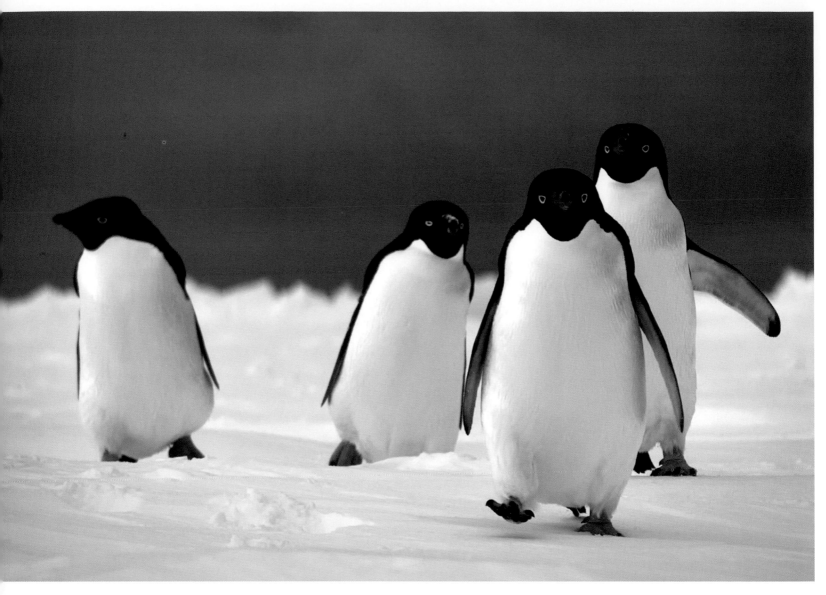

ANIMAL BEHAVIOUR

Happy feet

Graham Morgan, New South Wales

'Chaplinesque' antics by a group of Adelie Penguins stepping out at the Atka Ice Port in 2010. I saw them coming from quite a distance and positioned myself. They waddled right up to me, inspected the camera gear and continued on.

Atka Ice Port, Antarctica

■ Canon 1D MkIV, Canon 70–200mm f/4L IS lens, 1/640, f5.6, ISO 200

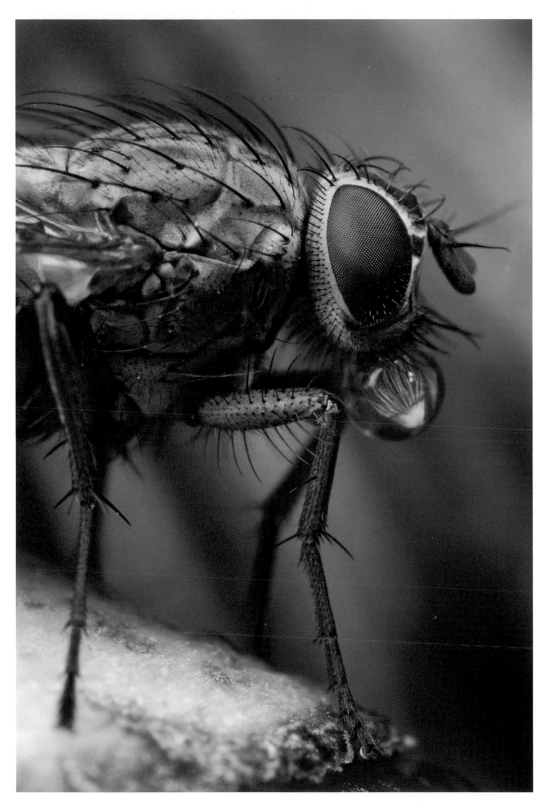

ANIMAL BEHAVIOUR
Fly blowing a bubble
Jenni Horsnell, New South Wales

On warm days I noticed that flies would rest after feeding and start blowing bubbles, repeatedly blowing and drawing the bubble back in. I believe flies do this to clean their mouthparts. The fly was close to a Eucalyptus flower in the background, which was refracted in the bubble.

Wagga Wagga, New South Wales

■ Canon 1D MkIV, Canon MP-E 65mm lens, twin flash, 1/250, f11, ISO 100

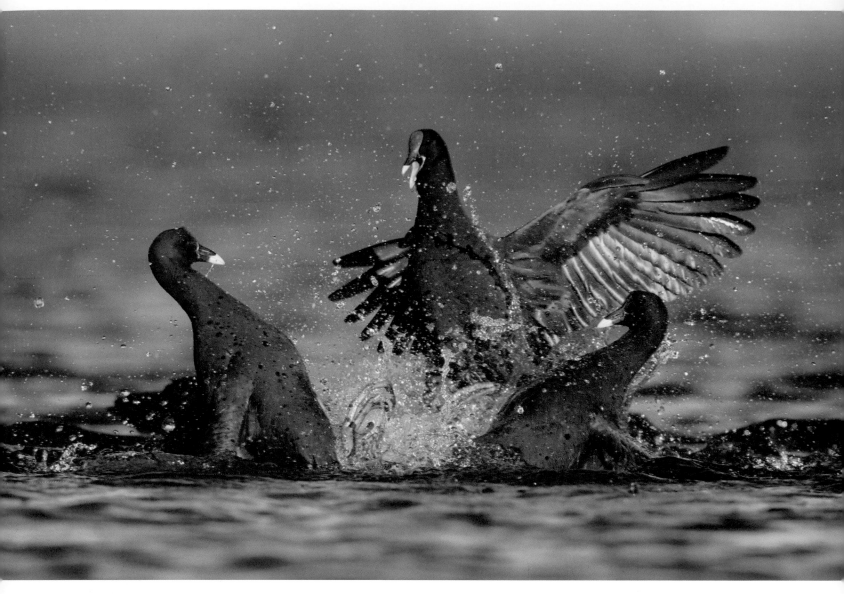

ANIMAL BEHAVIOUR

Dusky Moorhens brawl

Ofer Levy, New South Wales

During breeding season Dusky Moorhens are often involved in fights – probably over nesting areas and/or potential mating partners. In this image a pair of birds (in the centre and right) attacked the one on the left. The fight involves hitting each other with their long legs and toes and attempting to push each other under water. I stood in waist-deep water to get this low angle.

Centennial Park, Sydney, New South Wales

■ Canon 1D MkIV, Canon 600mm f/4L IS lens, 1/2500, f7.1, ISO 640

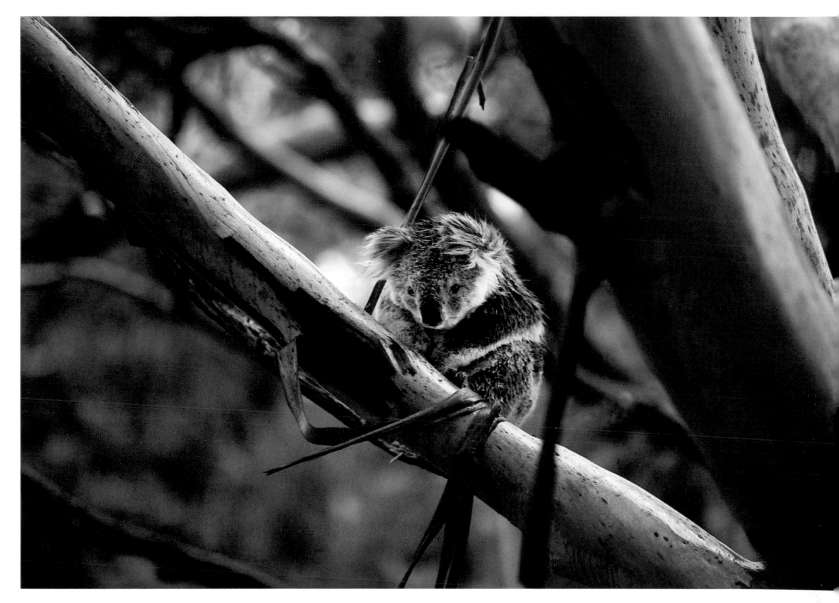

ANIMAL BEHAVIOUR

Koala (*Phascolarctos cinereus*) sheltering from the wind and rain

Tom Putt, Victoria

This section of forest is one of the best places I know to see and photograph Koalas – the gum vegetation is lush, the forest dense, and the trees relatively low. On this occasion we witnessed several unseasonal storm fronts and it was particularly cold. We spotted this Koala looking rather miserable. Rather than get closer, I decided to frame him huddled among the trees, seeking protection from the rain but to no avail.

Cape Otway, Victoria

■ Canon 5D, EF 70–200mm f/2.8L IS lens, 1/250, f2.8, ISO 400

ANIMAL BEHAVIOUR
Eagle ray migration
Ben Neale, Queensland

Even within the Great Barrier Reef Marine Park the Spotted Eagle Ray is an uncommon sight.
They are very shy by nature and their numbers are threatened through commercial fishing
bycatches, so to witness not just one but a travelling family of these graceful and beautiful
animals was a remarkable sight.

Wonga Beach, North Queensland

■ Canon 5D MkII, 1/500, f8, FL 25mm

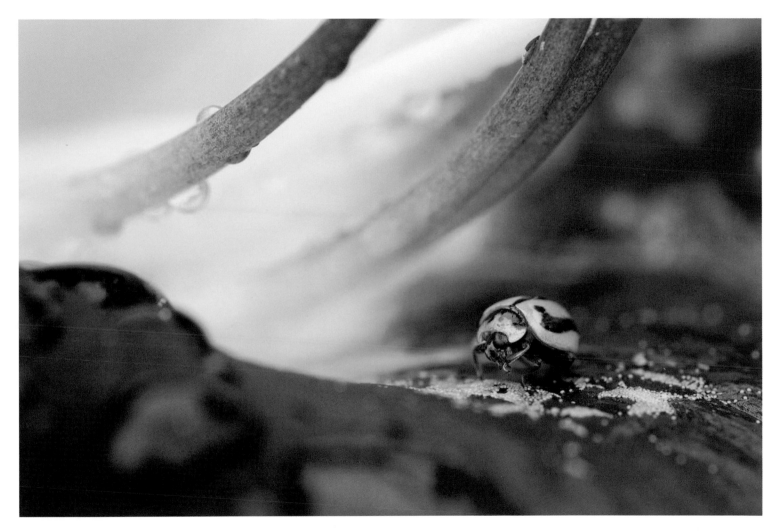

ANIMAL BEHAVIOUR

Nothing goes to waste

Louis Tsai, New South Wales

A ladybird, from the Coccinellidae family, enjoys a pollen meal during an interlude of summer rain. This docile-looking insect is actually a ferocious predator, and was feeding on aphids only moments before this photo was taken!

Centennial Park, Sydney, New South Wales

■ Canon 10D, Sigma 180mm f/3.5 macro lens, tripod, 1/125, f11, ISO 400

ANIMAL PORTRAIT

The subject must be photographed close up,
occupying at least 30 per cent of the frame.

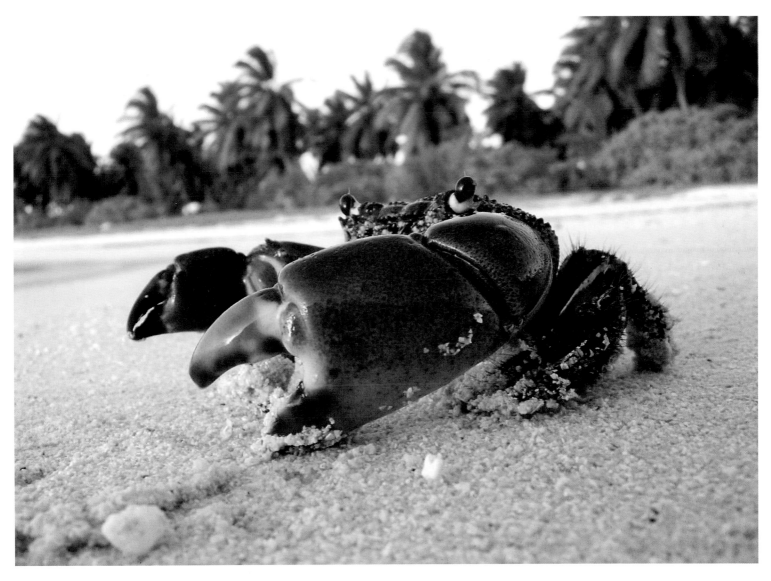

ANIMAL PORTRAIT – WINNER
Cocos crab

Michael Seebeck, Queensland

This is an opportunistic photograph – I was on the beach taking landscape scenes when I noticed this crab, a species I had not seen before, nor have I since. With a small camera I was able to show a crab's view of the world.

Home Island, Cocos (Keeling) Islands

■ Nikon Coolpix P4, 1/12, f6.8, ISO 50

'The low angle gives a wonderful perspective and depth, giving context of location and habitat. The close-up image emphasises the masculine quality of the subject.'
JUDGES' COMMENT

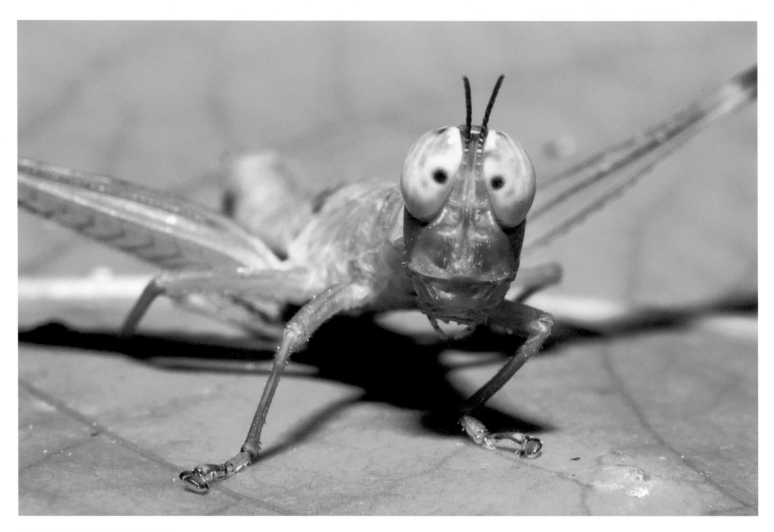

ANIMAL PORTRAIT – RUNNER-UP

Rainforest grasshopper

Andrew Ian Bell, Northern Territory

I found this engaging grasshopper nymph in lowland rainforest behind Mission Beach. As I approached, it started swaying from side to side as if assessing the lens. The play of light on the compound eyes created the illusion of pupils gazing back at the camera.

Mission Beach, North Queensland

■ Nikon D70, Sigma 50mm f/2.8 macro lens, 1/500, f22, single flash

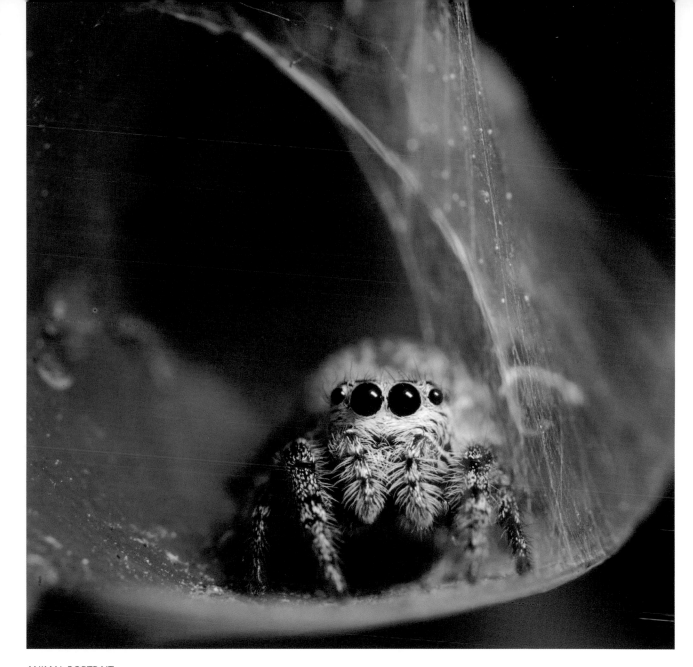

ANIMAL PORTRAIT

As snug as a Jumping Spider

Alan Kwok, New South Wales

You can find Jumping Spiders in nearly any garden. They are the most inquisitive of spiders, usually quickly turning their eyes towards a curious human. Some say it's hard to call spiders 'cute', but once you've seen a few Jumping Spiders you realise there's hardly a more fitting description.

Castle Hill, New South Wales

■ Canon 5D, MP-E 65mm 1–5x lens, 1/200, f11, flash

ANIMAL PORTRAIT
Hooded Plover take-off

Charlotte Young, Western Australia

An early morning walk on Four Mile Beach revealed a rather active pair of Hooded Plovers. The unspoilt shores that fringe Maria Island offer an ideal breeding habitat, lacking the all too present mainland pressures of beach-going 4WDs, jet skis, dog walkers and day trippers.

Maria Island National Park, Tasmania

■ Canon 1D MkIII, 500mm f/4L IS lens, 1/1250, 1.4x TC

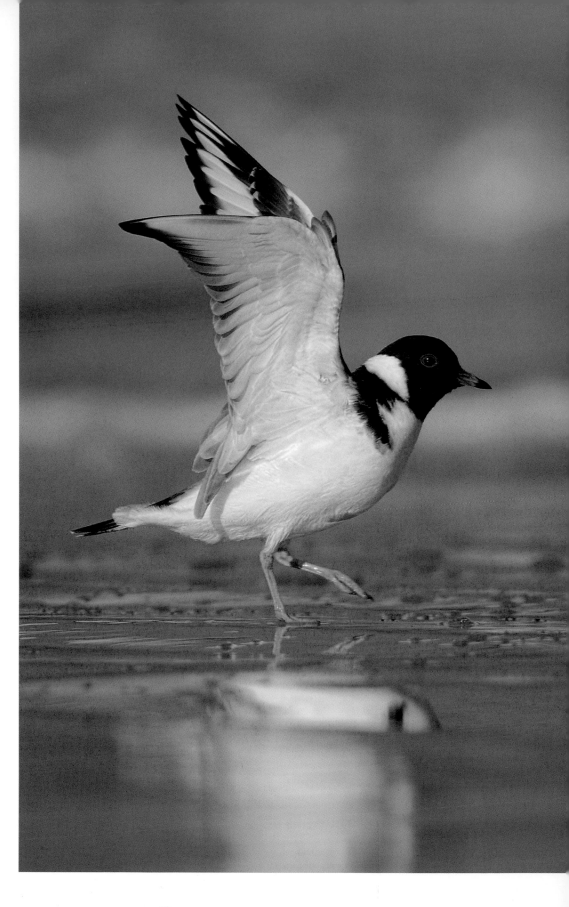

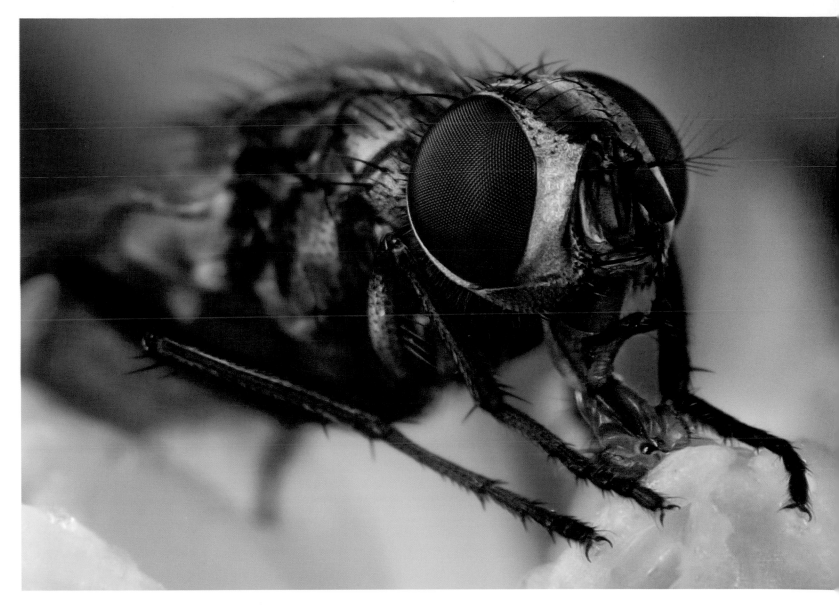

ANIMAL PORTRAIT

Fly feeding

Jenni Horsnell, New South Wales

I found this fly feeding on Sedum flowers. I took many images trying to capture the proboscis fully extended.

Wagga Wagga, New South Wales

■ Canon 1D MkIV, Canon MP-E 65mm lens, twin flash, 1/250, f13, ISO 400

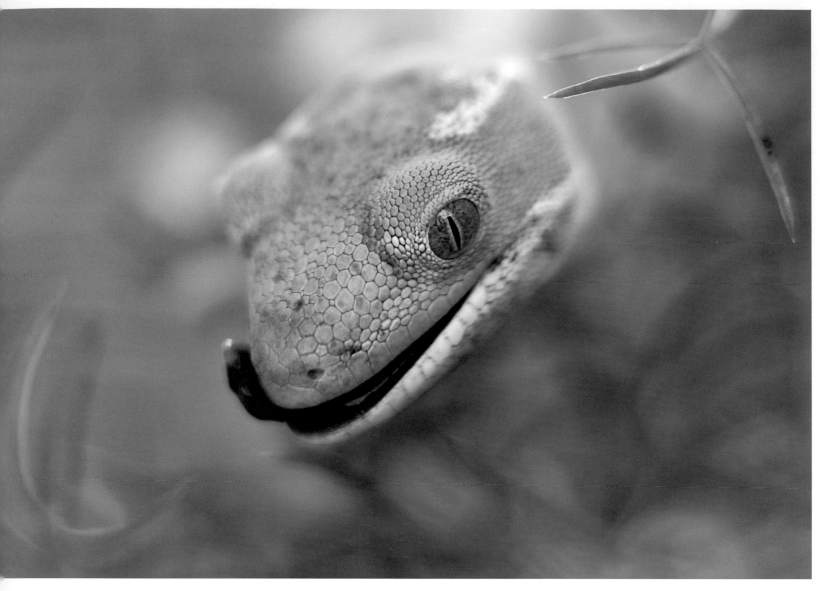

ANIMAL PORTRAIT
Northland Green Gecko

John O'Sullivan, Palmerston North, New Zealand

The Northland Green Gecko, *Naultinus grayii*, is named after the 19th century British zoologist John Edward Gray. *Naultinus grayii*'s elegant form is highlighted by a blue mouth lining and bright red tongue. New Zealand gecko populations continue to be threatened by habitat destruction and introduced mammalian predators.

Palmerston North, New Zealand. Kept under DOC licence. The DOC licence is a permit from the NZ Department of Conservation to keep native fauna.

■ Canon 40D, 160mm lens, 1/125, f2.8, ISO 200

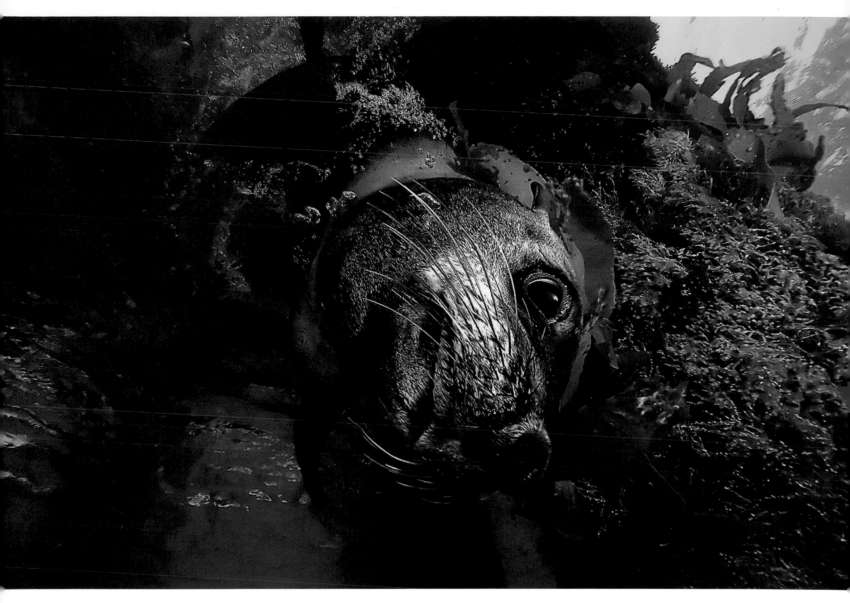

ANIMAL PORTRAIT

The Inspector

Matthew Tworkowski, Victoria

The Witches Hat is a refuge for a colony of Australian Fur Seals, which can be seen at this location all year round. This individual was the dominant male of the group. I estimated his weight at more than 200 kg, which was quite intimidating when he decided to charge at me as I was taking this shot.

The Witches Hat, Rye, Victoria

■ Nikon D70s, 1/125, f11, ISO 200

ANIMAL PORTRAIT

Common Mist Frog – *Litoria rheocola*
(Endangered)

Michael Williams, Victoria

As I was searching for rare and endangered frogs in a fast-flowing section of a stream in tropical North Queensland, this rather curious individual leaped onto a leaf beside me to pose beautifully for this photo.

Misty Mountains region, tropical North Queensland

■ Canon 5D MkII, Sigma 50mm f/2.5 compact macro lens, twin 550EX II flash units, 1/160, f18, ISO 100

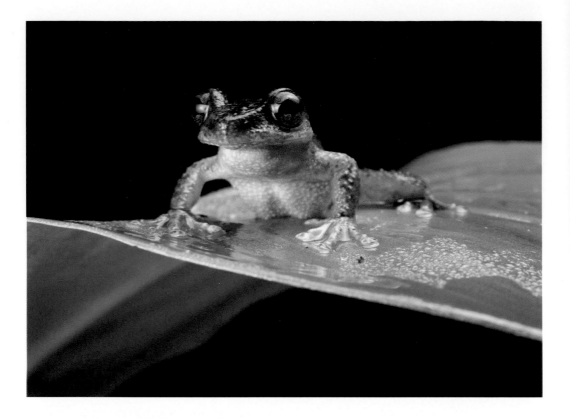

ANIMAL PORTRAIT

Morning maintenance

Paul Randall, Victoria

Crested Terns would have to be one of my favourite species of birds. They are always quite active, and their sleek looks, coupled with their angular body shape, make them very interesting photographic subjects.

Barwon Heads, Victoria

■ Canon 5D, 600mm f/4L (non-IS) lens, 1.4 TC, 1/640, f9.0, ISO 400

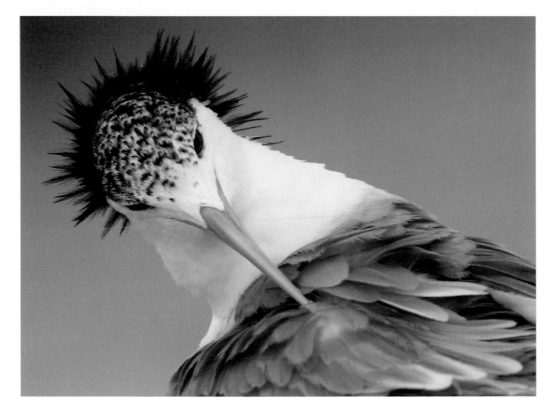

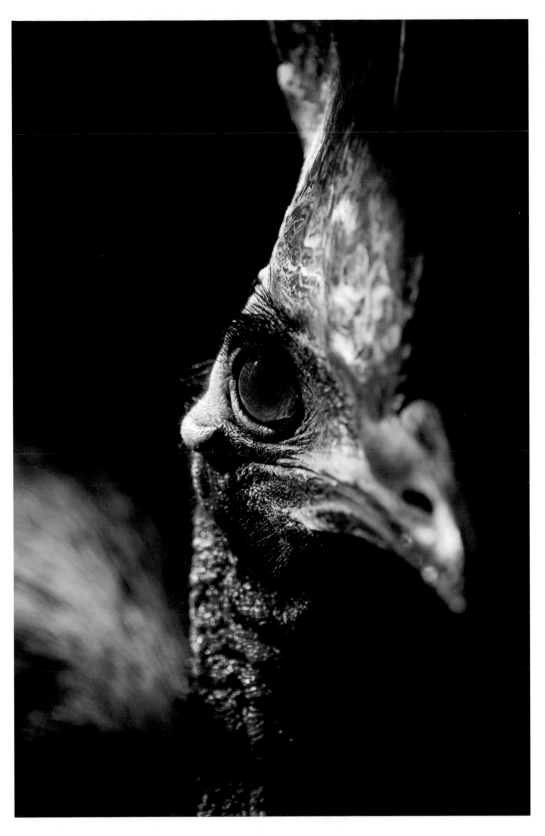

ANIMAL PORTRAIT

Be Casso-wary

Paul R Fulwood, Western Australia

As the sun's rays manage to pierce the shadows through the overlying foliage, distinct shadows of its wiry eyelashes are captured in the ominous eye of the often dangerous and feared Southern Cassowary.

Adelaide Zoo, South Australia

■ Canon 7D, EF 24–70mm f/2.8L lens, Aperture Priority, FL 43mm, 1/320, f2.8, ISO 100

BOTANICAL SUBJECT

This may be a portrait or a habitat shot.

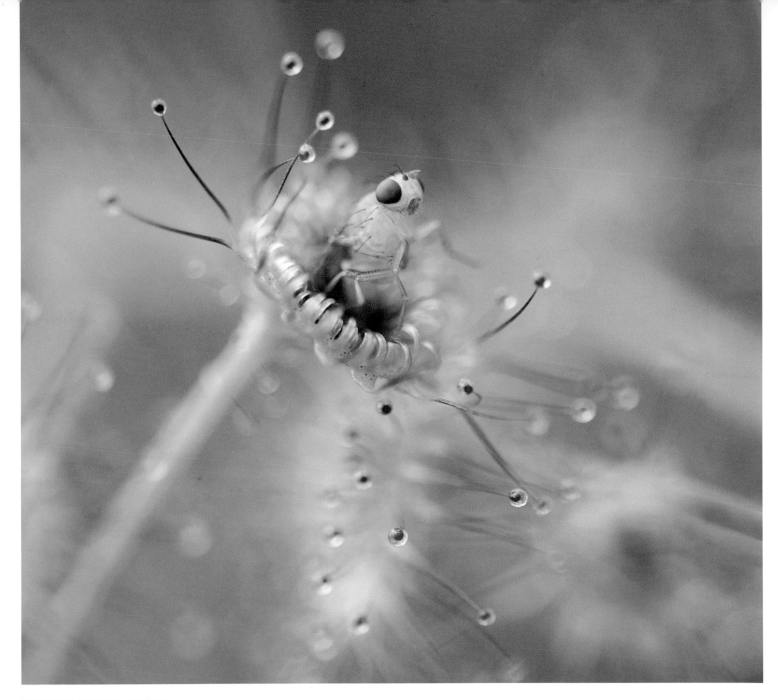

BOTANICAL SUBJECT – WINNER

Gotcha! Ensnared by a sundew

Tammy Gibbs, Western Australia

While photographing wildflowers in Kings Park, we noticed this Climbing Sundew (*Drosera macrantha*) eating a fly. The fly looked almost paralysed in its entrapped state, slowly being devoured by the carnivorous plant.

Kings Park, Perth, Western Australia

■ Nikon D300, Nikkor 105mm lens, 1/200, f5, ISO 200

'This image demonstrates skilful use of depth of field with nice cropping. An interesting ecological story.'
JUDGES' COMMENT

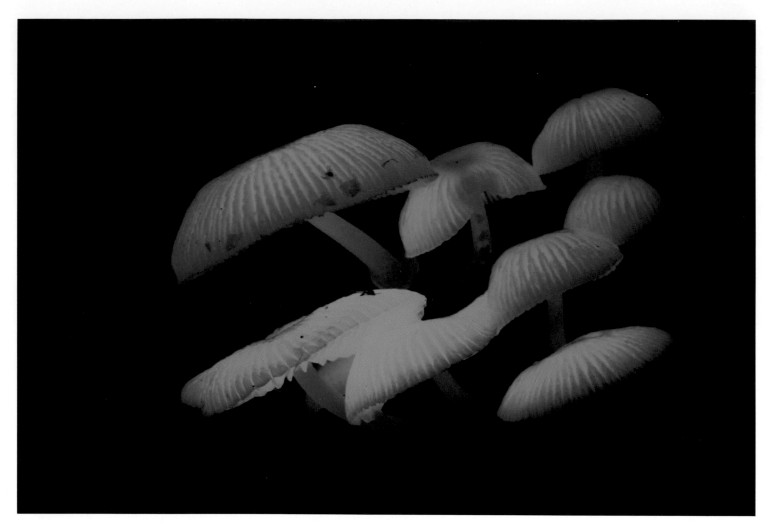

BOTANICAL SUBJECT – RUNNER-UP

Glowing mushie

Jack Shick, New South Wales

Like green eyes watching you as you follow the many winding paths through the forest at Lord Howe Island, this luminous fungus (*Mycena chlorophos*) grows on rotting wood after summer rain.

Forest floor, Lord Howe Island, New South Wales

■ Canon 7D, 100mm macro lens, 170 seconds, f14, ISO 100, tripod mounted

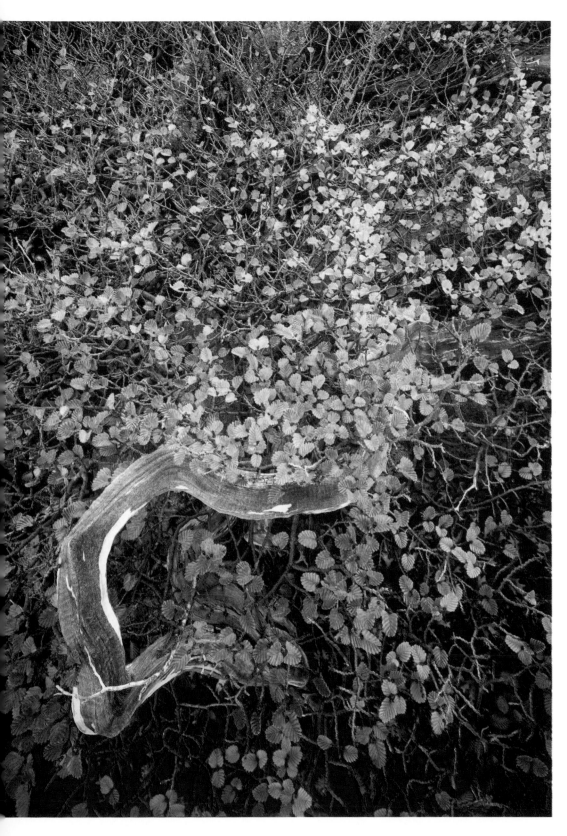

BOTANICAL SUBJECT
Deciduous Beech detail
Rob Blakers, Tasmania

Autumn colour of Deciduous Beech, Australia's only winter-deciduous tree. Living in rainforests and high mountains, Deciduous Beech or 'Fagus' grows very slowly. In the absence of fire, this surviving wind- and ice-shaped individual is likely to be hundreds of years old.

West Coast Range, Tasmania

■ Ebony 5x4 View camera, Schneider 65mm lens, 4 seconds, f22, Fuji Velvia

BOTANICAL SUBJECT

Ghost Gum, evening

Rob Blakers, Tasmania

Last light on the graceful trunk of a stately
Ghost Gum.

Trephina Gorge, East MacDonnell Range,
Northern Territory

■ Ebony 5x4 View camera, Schneider 65mm lens,
13 seconds, f22, forward tilt, Fuji Velvia

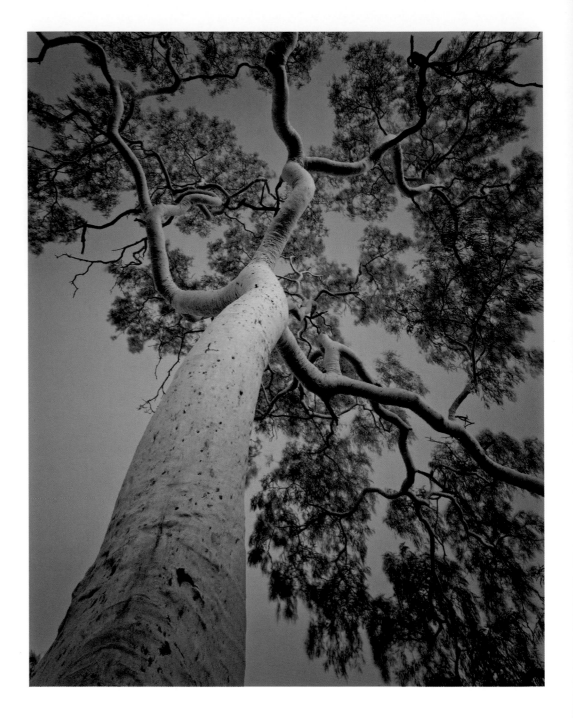

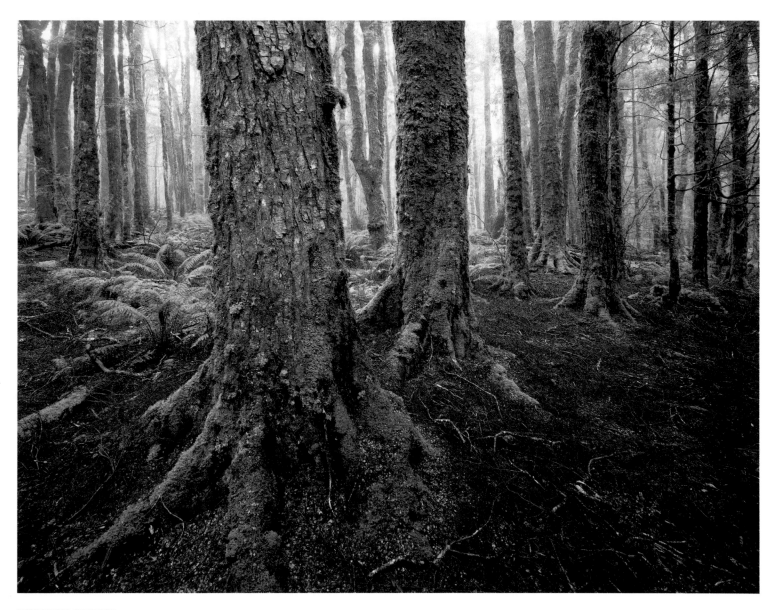

BOTANICAL SUBJECT

Myrtle forest

Rob Blakers, Tasmania

Mist wafts through mountain rainforest at day's end. This callidendrous or cathedral-like rainforest is dominated by myrtle, Tasmania's main rainforest tree. Individual trees live for upwards of 500 years, and the forest as a whole may be thousands of years old.

Rattler Range, north-eastern Tasmania

Ebony 5x4 View camera, Schneider 65mm lens, 13 seconds, f32, Fuji Velvia

BOTANICAL SUBJECT

Waxlip Orchid

Lynne McMahon, New South Wales

The exquisite beauty of small terrestrial orchids is often overlooked because of their diminutive size. This Waxlip Orchid (*Glossodia major*), measuring a mere 30 mm across, was photographed at the Rock Nature Reserve in spring 2010 after long-awaited drought-breaking rains resulted in an abundance of wildflowers.

The Rock Nature Reserve, The Rock, New South Wales

■ Nikon D300, VR 105mm macro lens handheld, 1/800, f5.6, ISO 1EV under 200

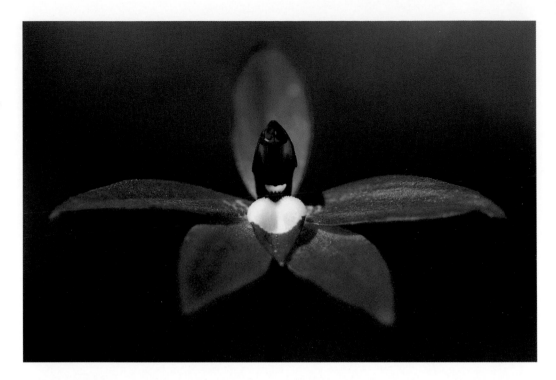

BOTANICAL SUBJECT

Beaufortia sparsa

Ian Robertson, Western Australia

Like exploding fireworks in an ochre-red sky, the stamens of the commonly called Swamp Bottlebrush catch the eye as they dart in every direction. Not a true bottlebrush, however, this is one of 19 species of Myrtaceae found naturally only in southern Western Australia.

Windy Harbour Road, part of the D'Entrecasteaux National Park, southern Western Australia

■ Nikon D300, Sigma 90mm macro lens, 1/500, f5.3, ISO 400

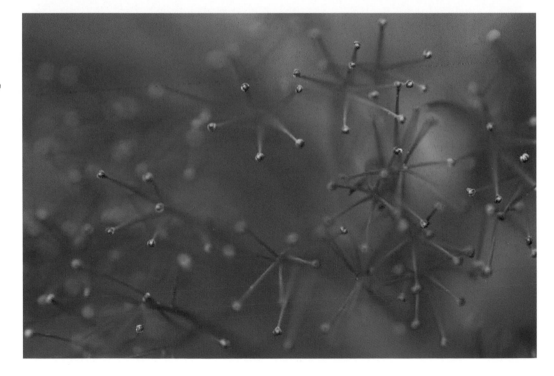

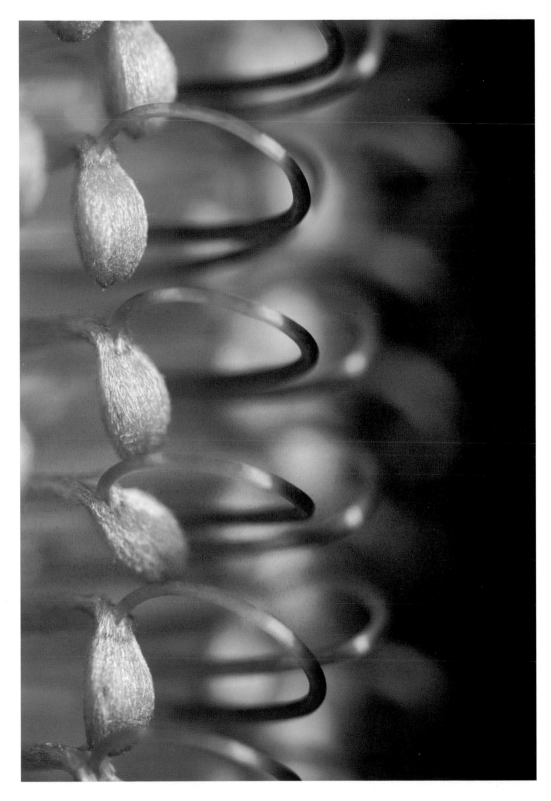

BOTANICAL SUBJECT
Banksia intricacies
Alan Kwok, New South Wales

Banksias are a common part of the Australian bush. In my life I had probably walked past a thousand Banksia flowers before I finally had a close look at one. The intricate details are clear to see if we take the time to look – photography gives us the ability to do so.

Dural, New South Wales

■ Canon 5D, MP-E 65mm 1–5x lens, 1/200, f4.5, flash

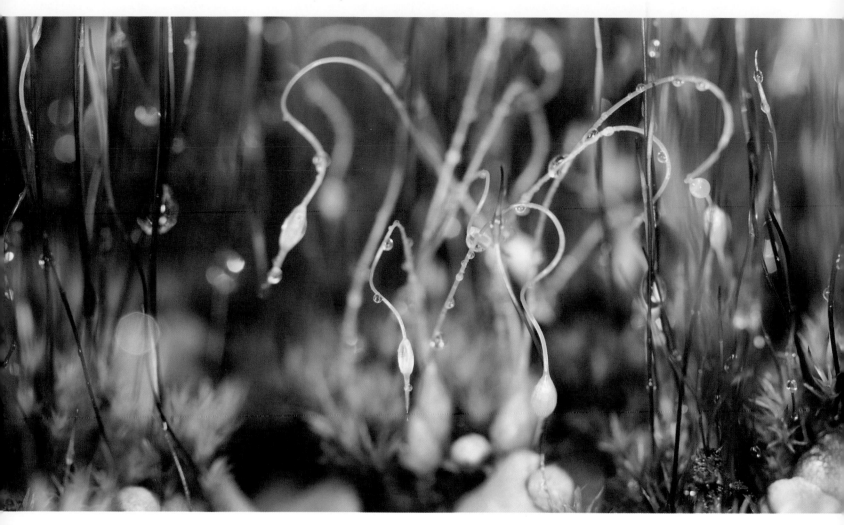

BOTANICAL SUBJECT

Sunday tea, moss sporophytes – Styx Valley

Wolfgang Glowacki, Tasmania

These tiny moss sporophytes abound in the lush forest of the south-west of Tasmania. Growing a mere 2 cm high, you have to hunt with a keen eye to find such small hidden treasures.

Styx Valley, Tasmania

■ Canon 1DS MkIII, 100mm macro lens, 1/250, f4.5

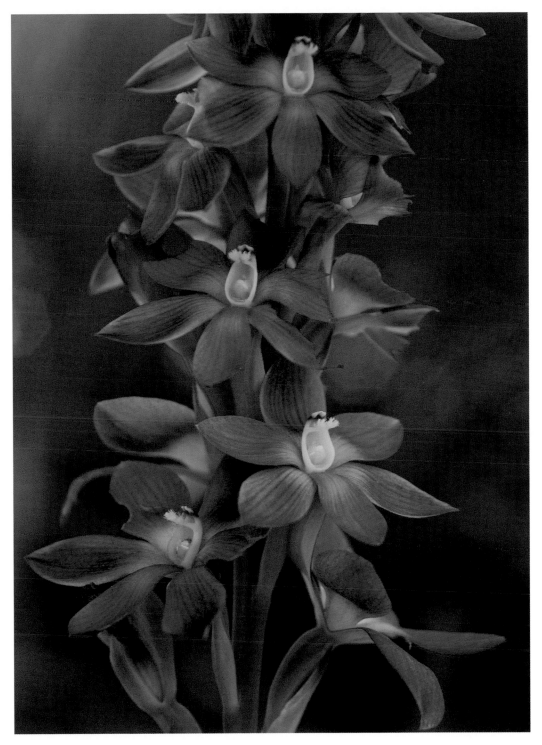

BOTANICAL SUBJECT

Giant Sun Orchid

Ted Mead, Tasmania

The morning sun backlights a splendid specimen of the Giant Sun Orchid in the open woodlands of Sympathy Hills. This orchid can grow up to a metre in height as it competes and thrives for full sunlight. It is often vulnerable to the browsing wallaby, so its best displays can be short lived.

Sympathy Hills Forest Reserve, Tasman Peninsula, Tasmania

■ Nikon D200, 60mm macro lens, 1/10, f8

UNDERWATER SUBJECT

This may be a portrait of an animal or plant, or a habitat shot.

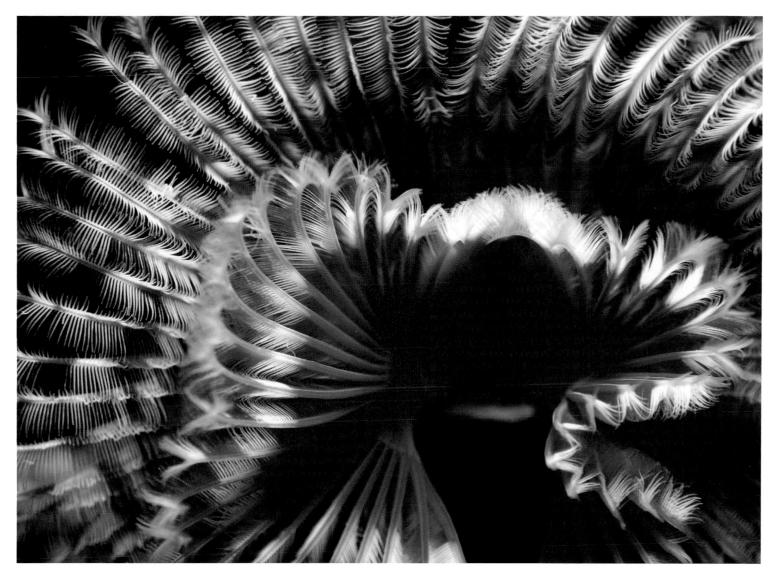

UNDERWATER SUBJECT – WINNER

Tube worm detail, *Serpula* sp.

Phil Mercurio, South Australia

Tube worms are common but often dismissed as photographic subjects given that they are shy and will retract if disturbed. With their delicate feather-like appearance, they can be quite spectacular up close. In this instance a dark blue sponge provides the backdrop, creating contrast and highlighting the worm's bright colours.

Port Hughes jetty, South Australia

■ Canon Ixus 980, 2 stacked Inon macro lenses, 1/60, f16, ISO 100

'A compositionally strong image with lovely, feathery sharpness. The use of natural pattern and colour, combined with the photographer's interpretation, makes for a beautiful composition.'
JUDGES' COMMENT

UNDERWATER SUBJECT – RUNNER-UP

Jellyfish starburst

Scott Portelli, New South Wales

A jellyfish infestation had taken over the
harbour, dominating the surrounding waters
with purple Cauliflower Jellyfish. The late
afternoon sun cast a beam of light through
a semi-translucent creature that had risen
from the depths. The water was murky and
the harbour was as still as a lake, creating an
eerie scene.

Tonga, South Pacific

■ Canon 5D Mk I, 17–40mm lens, 1/320, f18, ISO 320

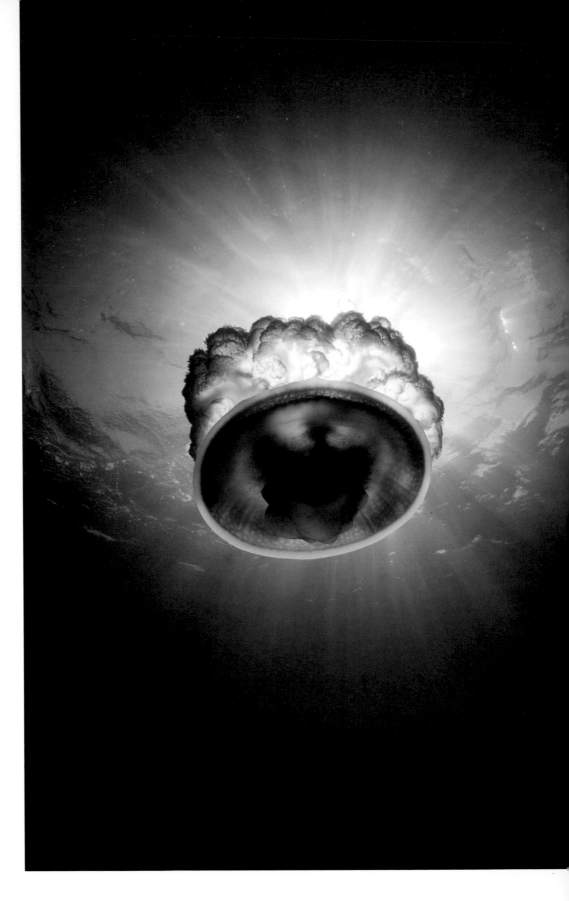

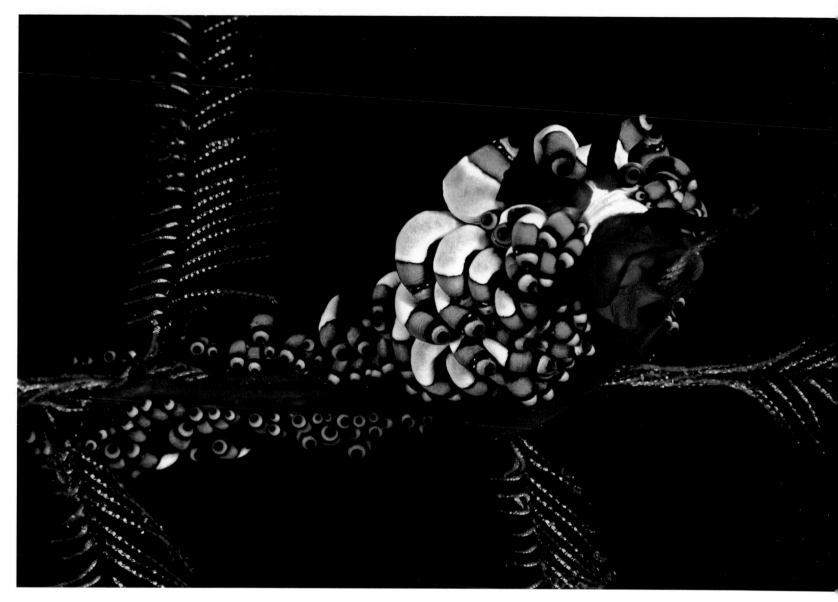

UNDERWATER SUBJECT

Colourful Nudi

Gary James Brennand, Western Australia

This is a *Cuthona yamasui*, which is a species of sea slug, or nudibranch. They are a shell-less marine Gastropod mollusc. I found this colourful little guy (about 3 cm long) while doing a night dive in the Komodo National Park. It appeared to be eating the white Stinging Hydroid (*Aglaophenia*) it was sitting on.

Komodo National Park, Indonesia

■ Nikon D300, Nikon 60mm lens, Aquatica underwater housing, 2 Sea & Sea YS110 strobes, 1/100, f20, ISO 400, spot metering, manual exposure

UNDERWATER SUBJECT

Body and gill detail of a nudibranch (*Ceratosoma brevicaudatum*)

Phil Mercurio, South Australia

Nudibranchs are often considered the butterflies or orchids of the ocean, and several are known for their vibrant colours. This macro image makes me think of natural abstract art – a small living canvas where you cannot help but be drawn in for another look.

Edithburgh jetty, South Australia

■ Canon 7D DSLR, 60mm macro lens, 1.4x TC and 12mm extension tube, 1/160 sec, f22, ISO 200

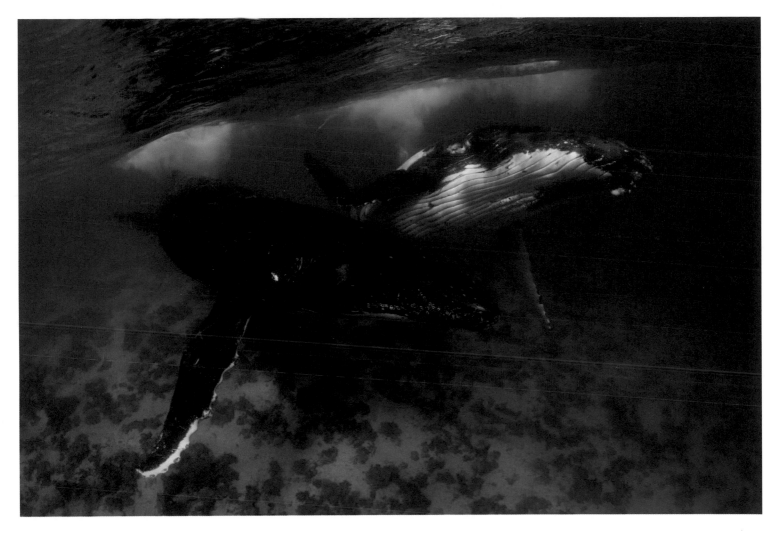

UNDERWATER SUBJECT

Shallow reef

Scott Portelli, New South Wales

A male Humpback slowly pursued a female along the shallow reef. I could hear the male singing, and the sound vibrated through my body as I got closer. The whales were in water no deeper than about 10 m as they glided past me in slow motion. It was an unforgettable moment.

Tonga, South Pacific

■ Canon 5D MkII, 17–40mm f/4L lens, 1/200, f13, ISO 320

UNDERWATER SUBJECT
Emergence

Scott Portelli, New South Wales

A Humpback calf emerged from the deep blue ocean below. One eye firmly fixed on me, it slowly crept closer like a torpedo in slow motion. As it grew large in my viewfinder I realised there were only a few inches between me and the young calf as it broke the surface to take a breath.

Tonga, South Pacific

■ Canon 5D MkII, 17–40mm f/4L lens, 1/200, f8, ISO 200

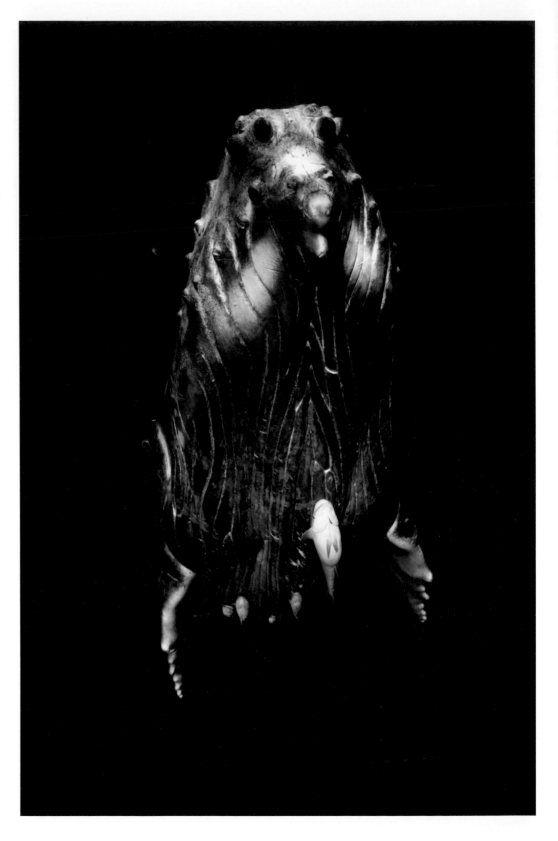

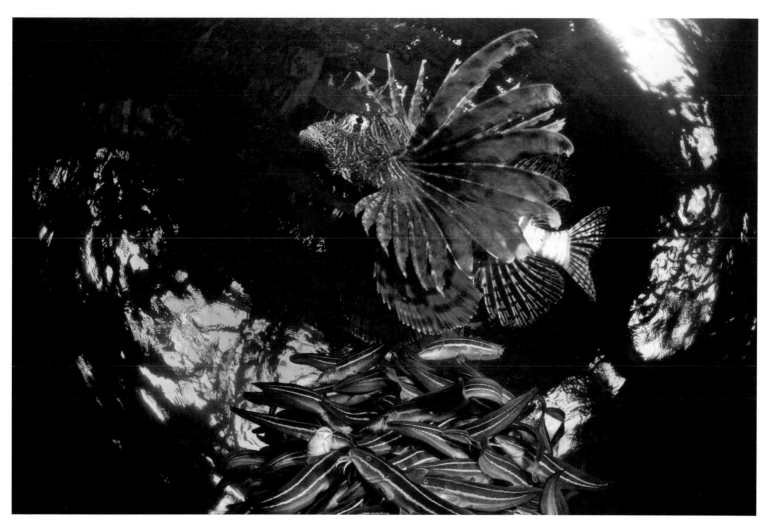

UNDERWATER SUBJECT

Beneath the jetty

Justin Gilligan, New South Wales

The Lord Howe Island lagoon is enclosed by the world's southernmost barrier reef. In the shadowy world beneath the Old Settlement Beach jetty unusual species come into close contact. This swirling mass of Striped Catfish with the fiery display of a Common Lionfish was an exciting chance encounter.

Lord Howe Island, New South Wales

■ Nikon D300, 10.5mm lens, Ikelite housing, twin DS160 strobes, 1/80, f8, ISO 400

UNDERWATER SUBJECT

Leafy Sea Dragon

Justin Gilligan, New South Wales

The Leafy Sea Dragon is the undisputed master of camouflage. As this individual peered into the camera, I was taken aback by the perfectly positioned filaments akin to blades of seaweed. Shortly after the encounter, it disappeared into a nearby forest of algae in the blink of an eye.

Edithburgh, South Australia

■ Nikon D300, 10.5mm lens, Ikelite housing, twin DS160 strobes, 1/250, f13, ISO 400

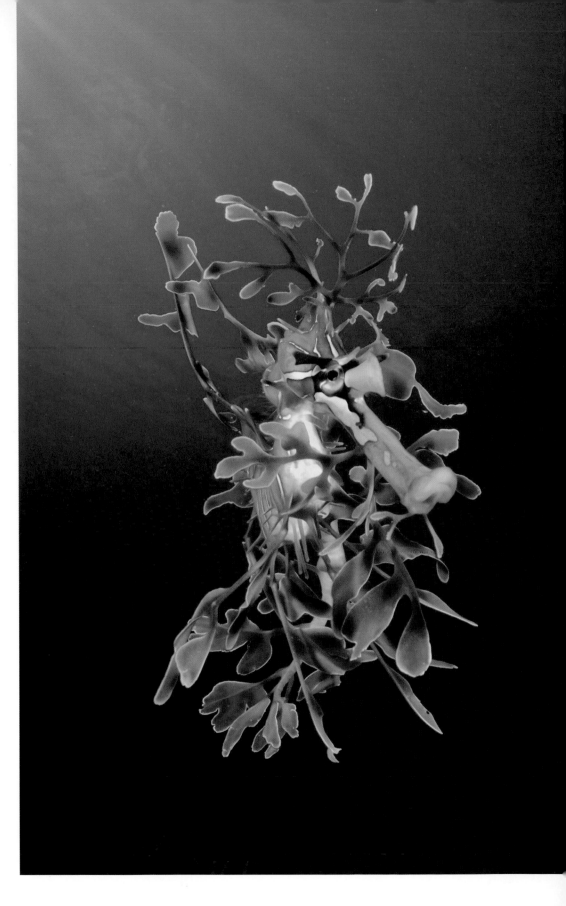

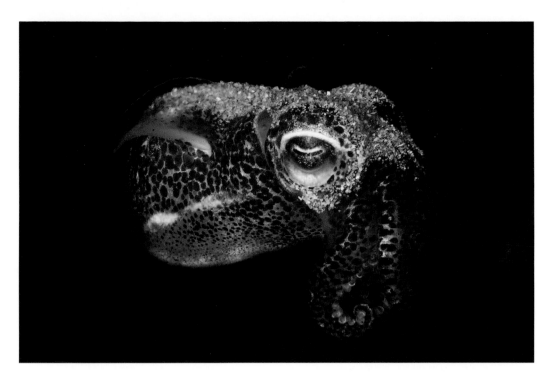

UNDERWATER SUBJECT

Greetings, Earthling

Matthew Tworkowski, Victoria

Southern Bobtail Squids are one of the ocean's little jewels and are often encountered under the veil of darkness, where they prefer to hunt and interact. They are usually found on a sandy bottom in shallow water and often change colour to mimic their surrounds.

Rye Pier, Victoria

■ Nikon D700, 1/60, f27, ISO 200

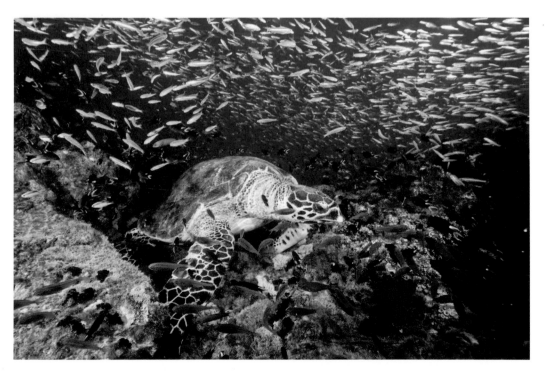

UNDERWATER SUBJECT

Green Turtle on the Yongala

Michael Seebeck, Queensland

This turtle was spotted feeding on algae and soft coral at the bow of the Yongala towards the end of the dive. I think I went into 'deco' to get down to the turtle's depth. The immense schools of small fish around it created quite a scene.

Yongala Wreck, north Queensland

■ Nikon D2Xs, 12–24mm f/4 lens at 12mm, 2 Inon strobes, Subal housing, 1/250, f6.3, ISO 200

WILDERNESS LANDSCAPE

The landscape or seascape must have minimal evidence of human interference.

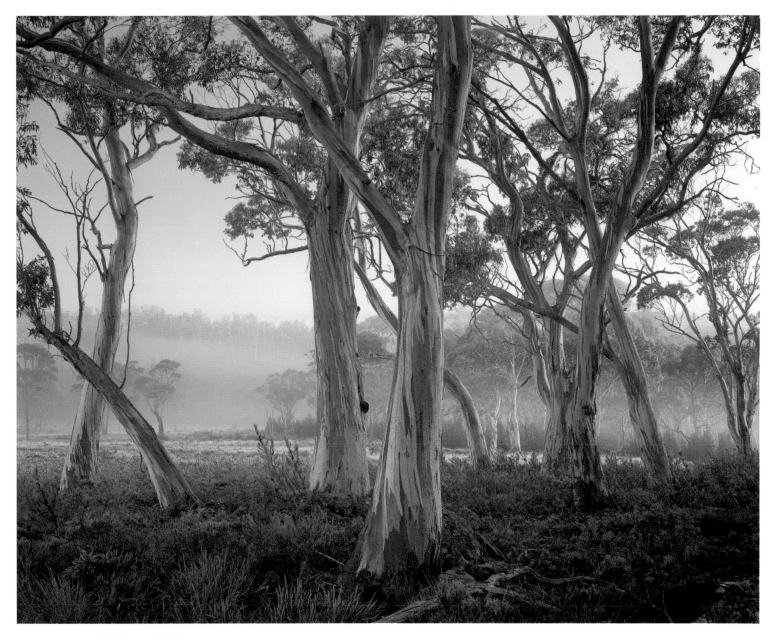

WILDERNESS LANDSCAPE – WINNER

Snow Gums, Navarre Plains

Rob Blakers, Tasmania

First light filters through an early winter's mist, highlighting the shapes of the eucalypts.
Behind lies the southern slopes of Mt Rufus, clothed in tall forest.

Navarre Plains, south of Lake St Clair, Tasmania

Ebony 5x4 View camera, Schneider 65mm lens, 2 seconds, f22, Fuji Velvia

*'This photograph has supreme delicate
light catching the fantastic bark on the
trees. There is a sense of stillness – it's too
cold for birdlife to disturb the serenity.'*
JUDGES' COMMENT

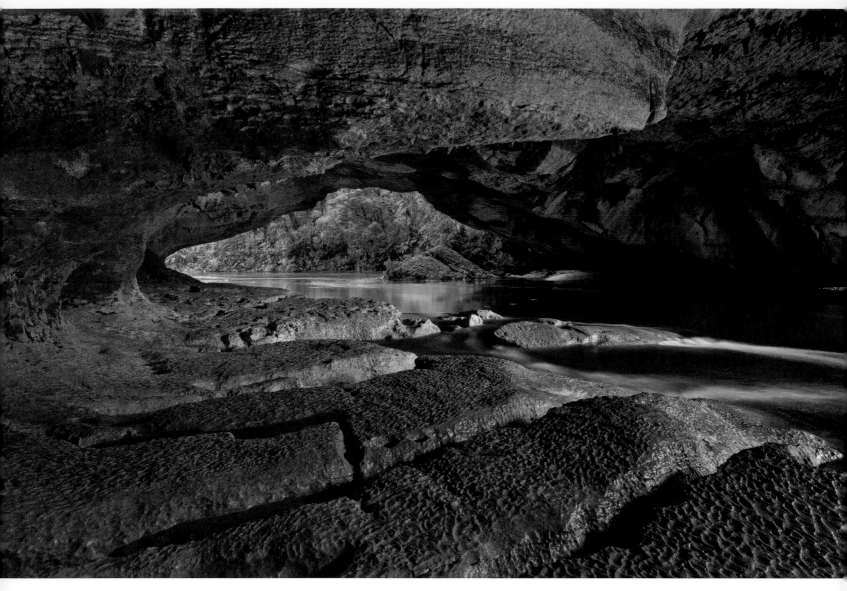

WILDERNESS LANDSCAPE – RUNNER-UP

Limestone arch

Andy Trowbridge, New Zealand

The Oparara river system has been sculpting the limestone into an intriguing complex of caves, arches and channels for millions of years. This arch is known as Moria Gate. I was intrigued with textures in the limestone and how they contrasted with the smooth tea-coloured water. The 'window' of native bush gives the viewer a glimpse of what's on the other side.

Oparara Basin, Karamea, South Island, New Zealand

■ Canon 5D, 17–40mm f/4L lens at 17mm, 10 seconds, f11, ISO 100

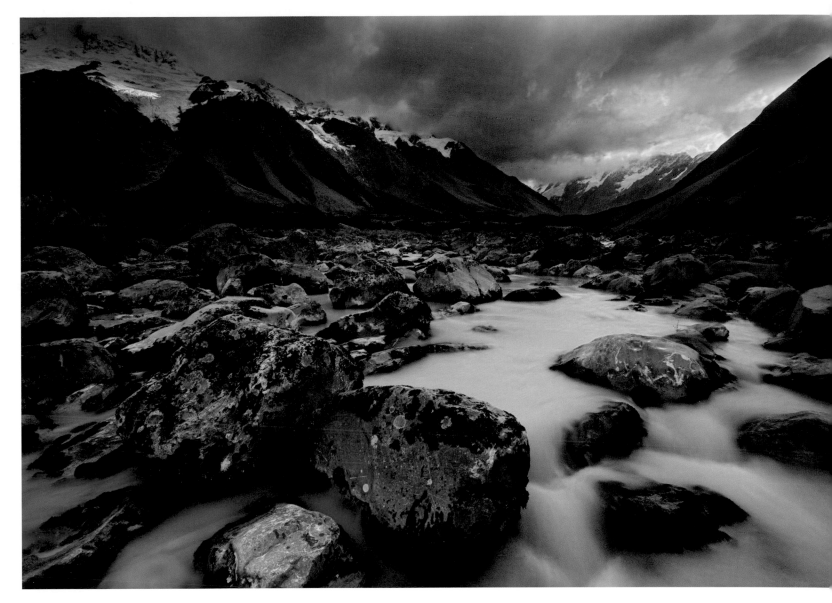

WILDERNESS LANDSCAPE

The valley of fire

Kah Kit Yoong, Victoria

The conditions looked so poor from Mt Cook village that I had been prepared to sit out the dawn shoot. However, as sunrise approached I noticed a small hole appear in the sky – not particularly promising but tantalising enough for me to run full bore down into the valley.

Mount Cook, Aoraki National Park, New Zealand

■ Canon 5D MkII, Canon 16–35mm f/2.8L lens, 1.3 seconds, f14, ISO 100, Singh-Ray neutral density graduated filter, Gitzo tripod

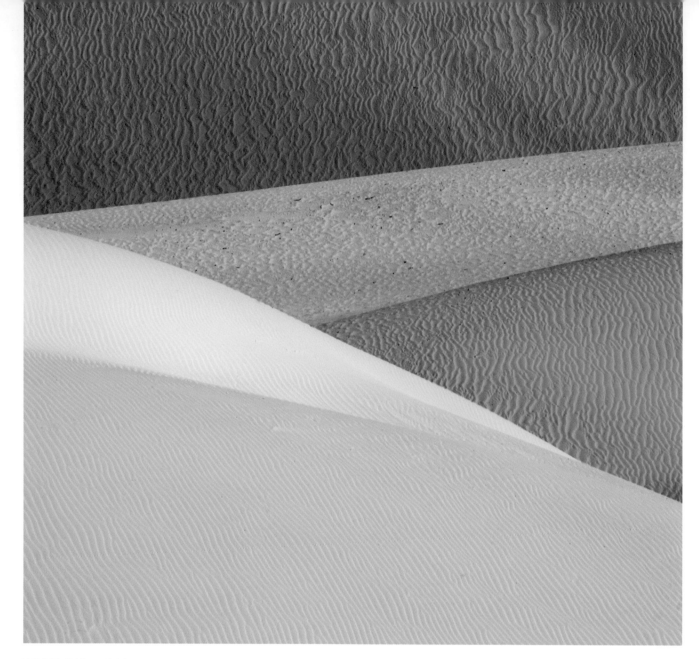

WILDERNESS LANDSCAPE
Sand dunes

Andrew Davoll, Western Australia

Leaving well before dawn, I got to these sand dunes as first light was breaking. Some of the dunes were in light and others still in shadow or partial shadow. Compressing the perspective by using a long lens made the dunes look as if they were made of different-coloured sands.

North of Jurien Bay, Western Australia

■ Nikon D200, Sigma 70–200mm zoom lens at 200mm, f22

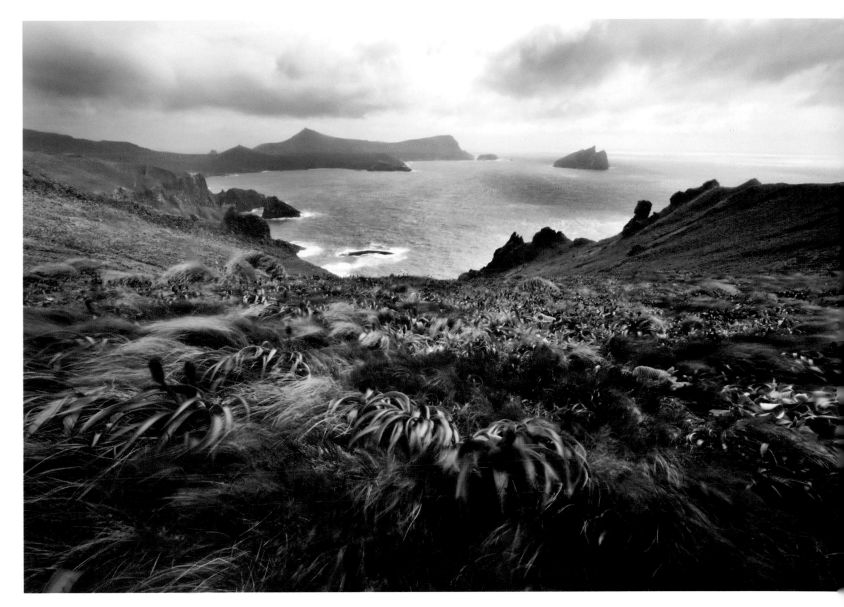

WILDERNESS LANDSCAPE

Westerly wind

Michael Rossi, New South Wales

At the top of Col Lyall ridge I found myself shooting into a 100 km/hour headwind that was being funnelled up this gully from the sea. I wanted to capture the tussock grass and megaherbs flailing in the wind – not an easy task when I was practically being blown over myself. But I set up my tripod, held on tight and managed to capture this long exposure.

Campbell Island, New Zealand

■ Canon 5D MkII, 16–35mm lens at 17mm, 1/10, f22

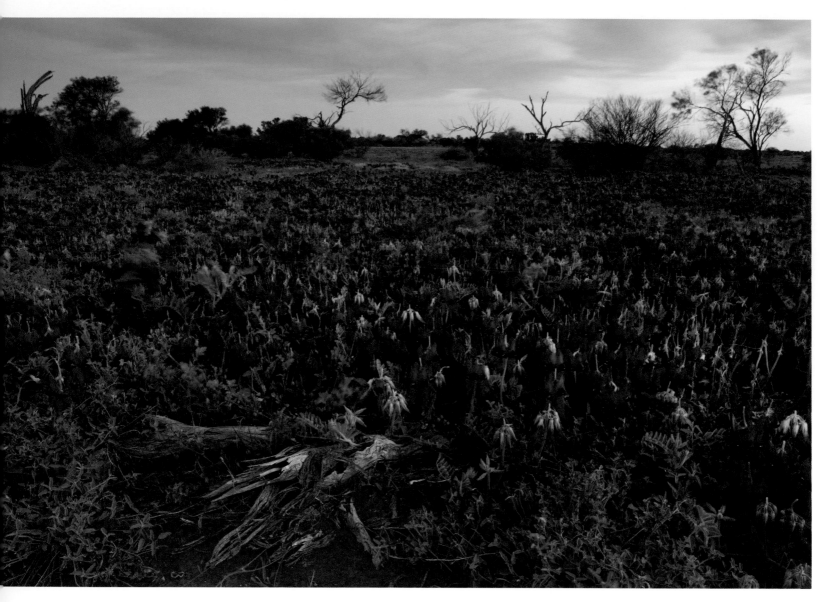

WILDERNESS LANDSCAPE
Desert colour
Morne de Klerk, South Australia

Where you are right now is a destination for someone else. You don't have to travel to find interesting things to photograph – all you have to do is open your eyes and look around you.

Roxby Downs, South Australia

■ Canon 5D MkII, 25 seconds, f22, side lit with spotlight in various areas (painting with light)

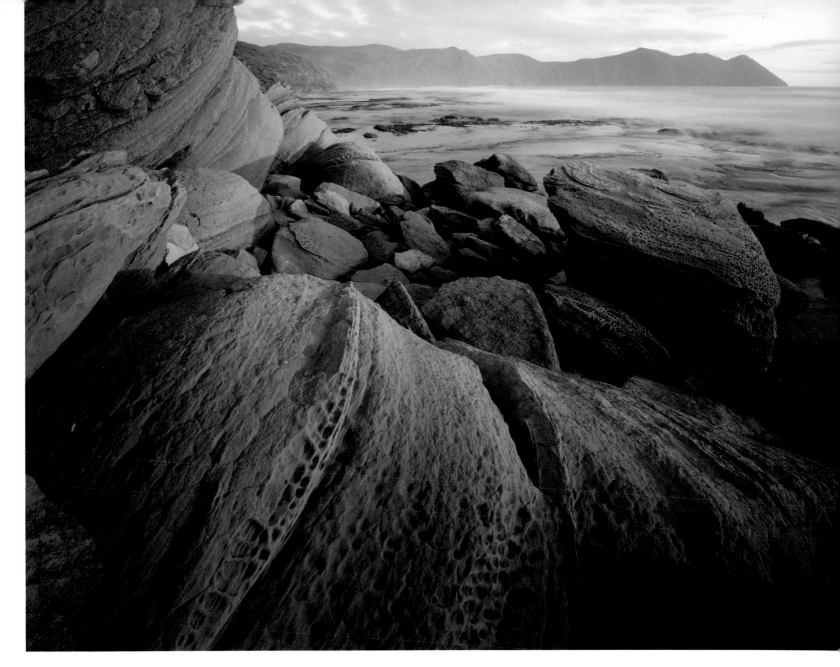

WILDERNESS LANDSCAPE

South coast sandstone

Rob Blakers, Tasmania

Last light at South Cape Bay. South East Cape, the southern-most point of mainland Tasmania, lies behind tumbled sandstone blocks, the eroded remnants of adjacent cliffs.

South Cape Bay, southern Tasmania

■ Ebony 5x4 View camera, Schneider 65mm lens, 2 seconds, f22, forward tilt, Fuji Velvia

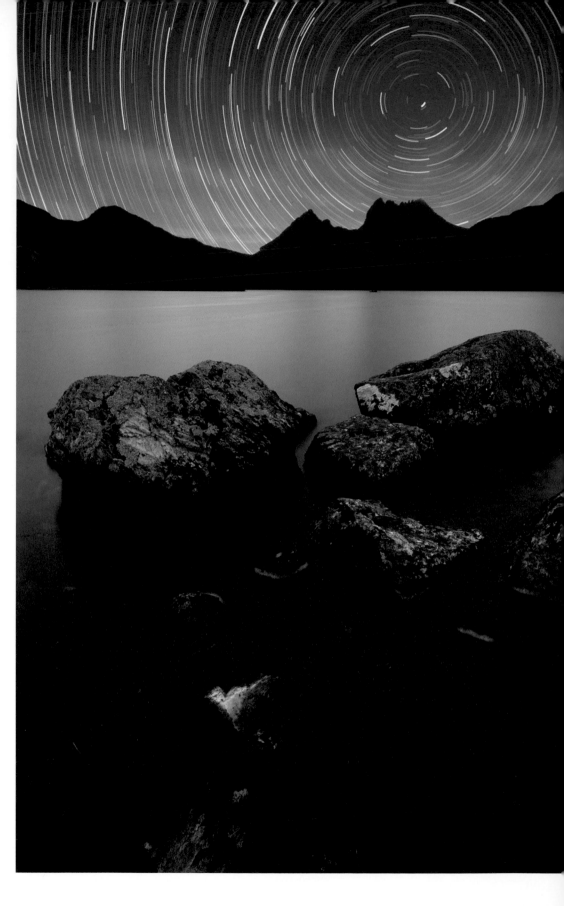

WILDERNESS LANDSCAPE

Vincent (Starry Starry Night) – a tribute to the legendary painter Vincent Van Gogh

Timothy Poulton, New South Wales

I planned a trek to the summit of Cradle Mountain, starting the morning at 4 am on Lake St Clair to get a stunning star trail. Blessed with a clear morning, I froze for over an hour and only had a small amount of cloud come in at the end of the exposure. The Paddymelons and Spotted Quolls all had a good laugh.

Cradle Mountain, Tasmania

■ Nikon D3X, 18mm Carl Zeiss lens, f16, ISO 100

WILDERNESS LANDSCAPE
Mount Hotham valley
Tom Putt, Victoria

After fires ravaged the alpine areas a few years back, much of the vegetation, including the Snow Gums, was left dead, never to regenerate. In this image the ridge tops are lined with these dead trees. I loved the repetition, with the ridge lines intersecting one another.

Mount Hotham, Victoria

■ Canon 5D MkII, EF 70–200mm f/2.8L lens, 0.6 seconds, f16, ISO 100

THREATENED SPECIES

The subject or subjects may be photographed in any of the following ways:

- in portrait
- engaged in natural activity
- in natural habitat.

All entries in this section must be accompanied by an official reference
(valid for any of the five years prior to the date of close of entries)
from the relevant country's government agency concerned with flora and fauna
verifying the subject's Threatened, Rare, Vulnerable or Endangered status.

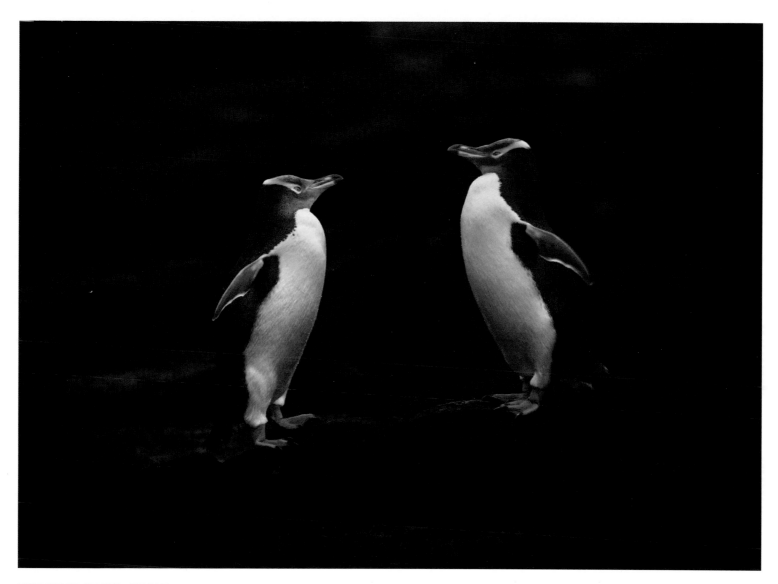

THREATENED SPECIES – WINNER

Yellow-eyed Penguin salute

Kah Kit Yoong, Victoria

After photographing the sunset, a couple of Yellow-eyed Penguins returned from the sea. I exchanged my wide-angle lens for a telephoto to capture some of their behaviour. The seabed they were standing on is petrified wood, remnants of an ancient forest. Who would have thought one could ever see a penguin on a tree?

Curio Bay, Catlins, New Zealand

■ Canon 5D MkII, Canon 300mm f/4L IS lens, 0.4 seconds, f5.6, ISO 800, Gitzo tripod

'Great composition and exposure of the world's rarest and most cryptic penguin.'
JUDGES' COMMENT

Status: The Yellow-eyed Penguin (*Megadyptes antipodes*) is listed as Endangered.

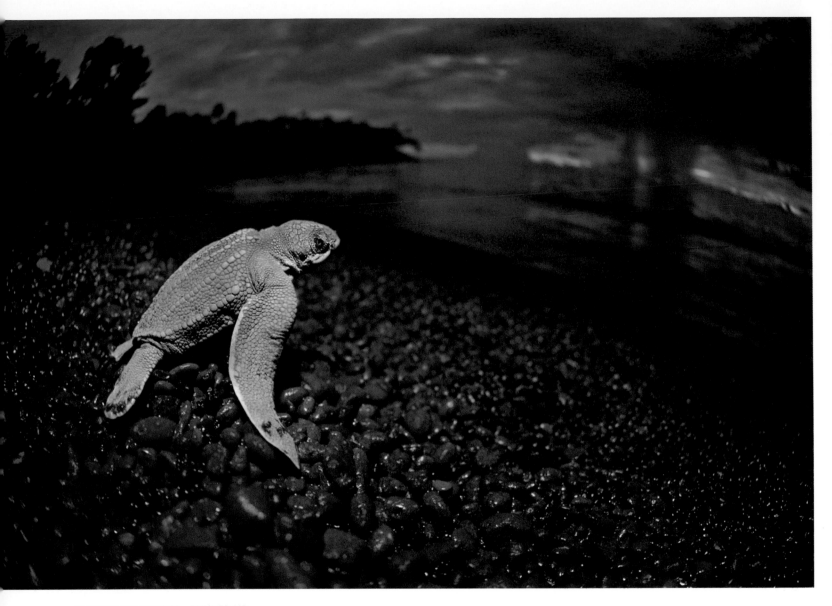

THREATENED SPECIES – RUNNER-UP

Leatherback hatchling's last stand

Anthony Plummer, Victoria

This ocean-bound Leatherback Turtle hatchling is one of thousands saved by a local conservation program run by Tetepare Island's descendants. Former turtle hunters are now champions for the Leatherbacks, dedicating days and nights throughout the breeding season to help rescue the species from the brink of extinction.

Baniata, Rendova Island near Tetepare, Western Province, Solomon Islands

■ Nikon D200, AF DX Fisheye-Nikkor 10.5mm f/2.8G ED lens, 1/40, f4.5, ISO 400

Status: The Leatherback Turtle (*Dermochelys coriacea*) is listed as Critically Endangered.

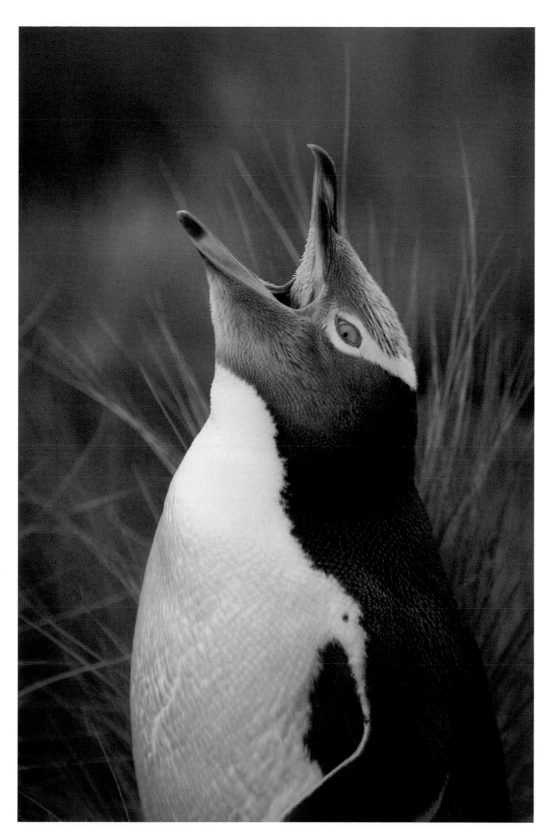

THREATENED SPECIES

Yellow-eyed Penguin yawn

David Stowe, New South Wales

Seeing and being so close to this endangered species while photographing from a hide was an unforgettable experience. This penguin came into its roost as the sun was going down and settled in front of us. Its yellow eyes and markings blended beautifully with the grass behind. Capturing this bird opening its bill to show the rasp-like texture of the mouth was a huge thrill.

Otago Peninsula, New Zealand

■ Canon 5D, 300mm f/4L IS lens, 1/100, f4, ISO 640

Status: The Yellow-eyed Penguin (*Megadyptes antipodes*) is listed as Endangered.

THREATENED SPECIES

Turquoise Parrot in green and gold

Dean Ingwersen, Victoria

I set up in front of this beautiful perch, hoping something nearby would land on it. After a long wait I saw a flash of gold flying towards the perch and this male landed right in front of me, posing happily while I photographed it. One of those magic moments!

Chiltern-Mt Pilot National Park, Victoria

■ Canon 7D, 500mm f/4L IS lens, 1.4x TC, 1/400, f10, ISO 160

Status: The Turquoise Parrot (*Neophema pulchella*) is listed as Vulnerable in New South Wales and Threatened in Victoria.

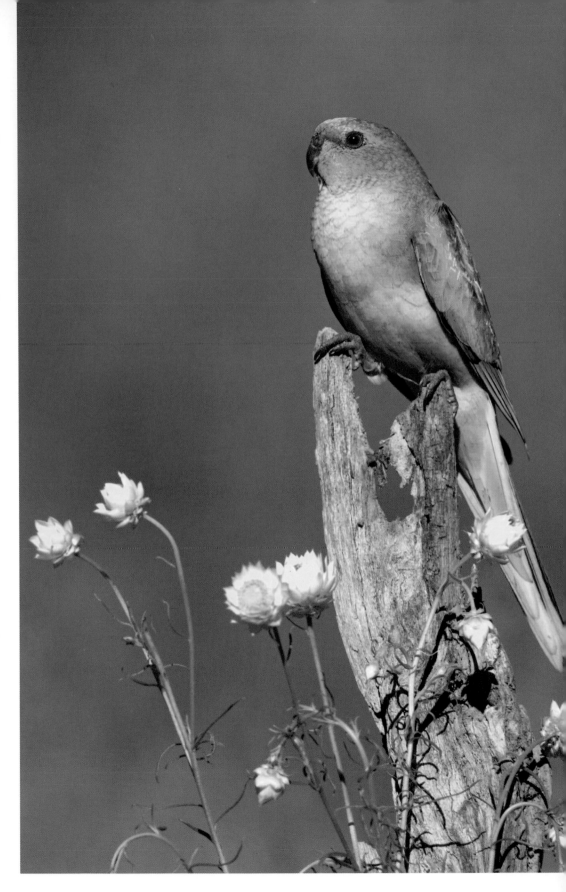

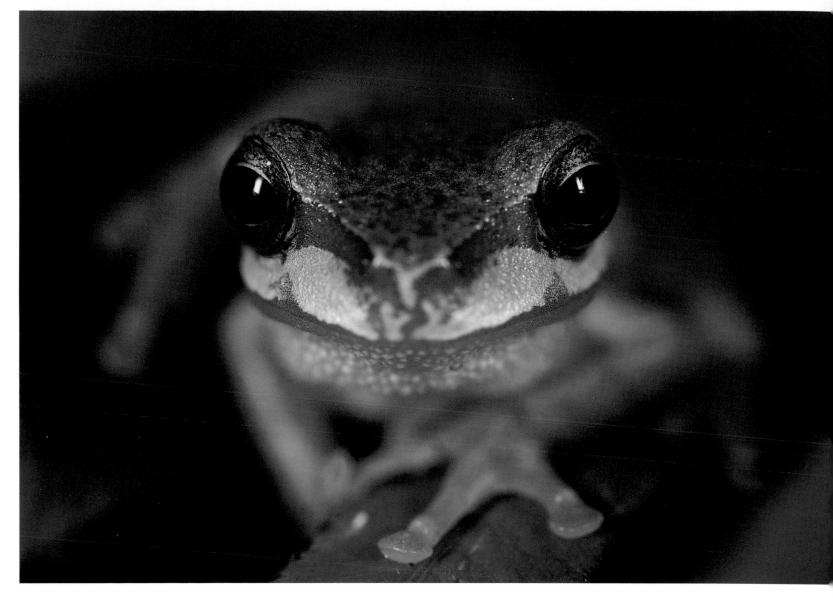

THREATENED SPECIES

Cascade Treefrog

Ben Nottidge, Queensland

Like some other wet-forest frogs, this species suffered significant population declines a few decades ago due to habitat destruction in various forms and, most likely, chytrid fungus. In recent times, however, some populations have increased and it is to be hoped that this will continue.

Conondale Range, south-east Queensland

■ Canon 40D, 60mm macro lens, twin flash, 1/250, f4.5, ISO 100

Status: The Cascade Treefrog (*Litoria pearsoniana*) is listed as Vulnerable in Queensland.

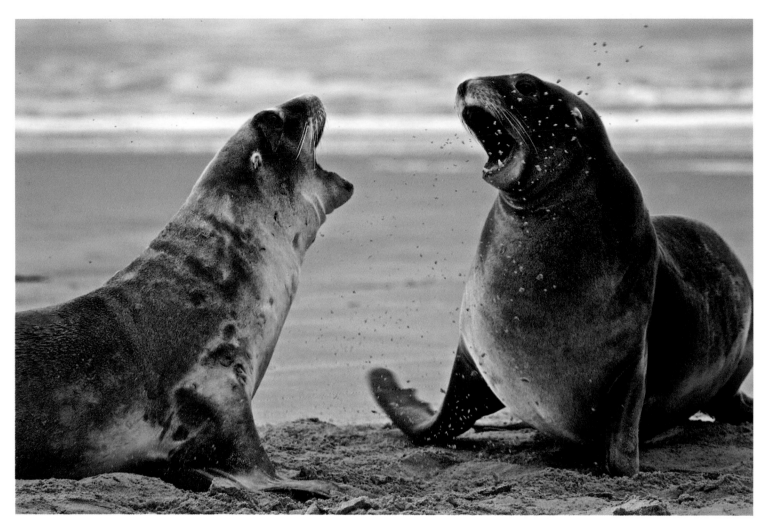

THREATENED SPECIES

Play fight

Craig Bullock, New Zealand

The New Zealand Sea Lion is an elusive creature, with less than 200 individuals remaining on the mainland. Despite hearing of several places to see them, I had several failed attempts at even catching a glimpse. Finally, my luck changed and I saw a group, including these two playful youngsters, and got this shot.

Catlins, New Zealand

■ Canon EOS 7D, 100–400mm f/4–5.6L IS lens, 1/320, f6.3, ISO 400, fill flash

Status: The New Zealand Sea Lion (*Phocarctos hookeri*) is listed as Vulnerable.

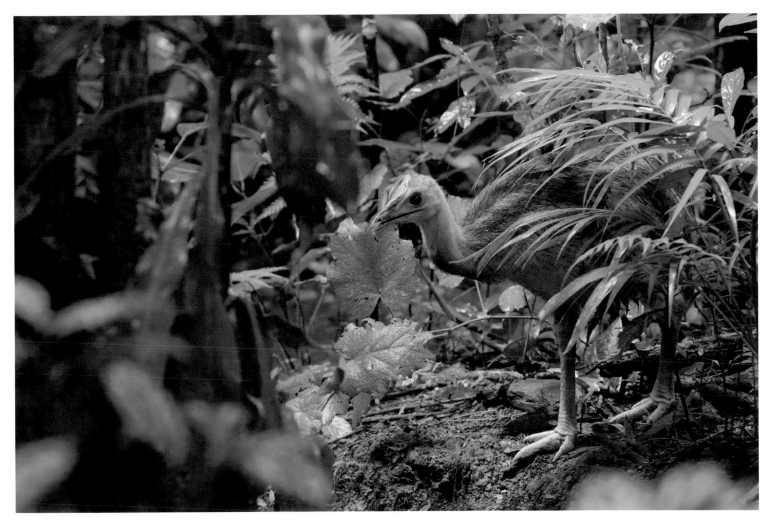

THREATENED SPECIES

Southern Cassowary chick in rainforest

Dave Watts, United Kingdom

We had been searching rainforest near Kuranda hoping to spot a Southern Cassowary. We were thrilled to find a male with three chicks but the group was very difficult to photograph in the dense rainforest. One chick, though, was quite inquisitive and I was fortunate to obtain some images.

Near Kuranda, Queensland

■ Nikon D300S, Nikon 70–200mm f/2.8 AFS VR lens, 1/25, f4, ISO 800

Status: The Southern Cassowary *(Casuarius casuaris)* is listed as Endangered.

THREATENED SPECIES

Hooded Plover

Paul Randall, Victoria

This small plover was darting around and feeding on small scraps of food that the crashing waves were bringing in. It seemed to always have one eye on me and the other eye on the incoming tide.

Point Roadknight, Victoria

■ Canon 5D, 600mm f/4L (non-IS) lens, 1.4x TC, 1/4000, f7.1, ISO 400

Status: The Hooded Plover (*Thinornis rubricollis*) is listed as Threatened in Victoria.

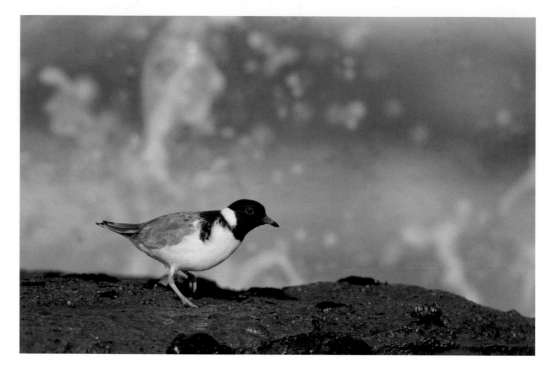

THREATENED SPECIES

Kea of the mountains

Wendy Broekx, South Australia

The Kea, one of the few alpine parrots in the world, is known for its intelligence and curiosity, both vital to its survival in a harsh mountain environment. It was a tough but rewarding climb to the top of Avalanche Peak, especially with the Keas at the top to greet us.

Avalanche Peak, Arthurs Pass, New Zealand

■ Canon 1D MkIII, EF 24–70mm f2.8L lens, 1/1250, f5.6, ISO 400

Status: The Kea (*Nestor notabilis*) is listed as Vulnerable.

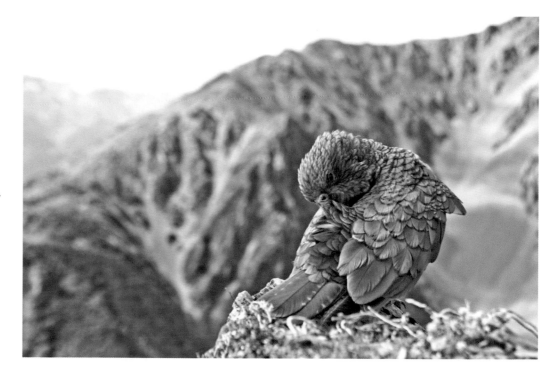

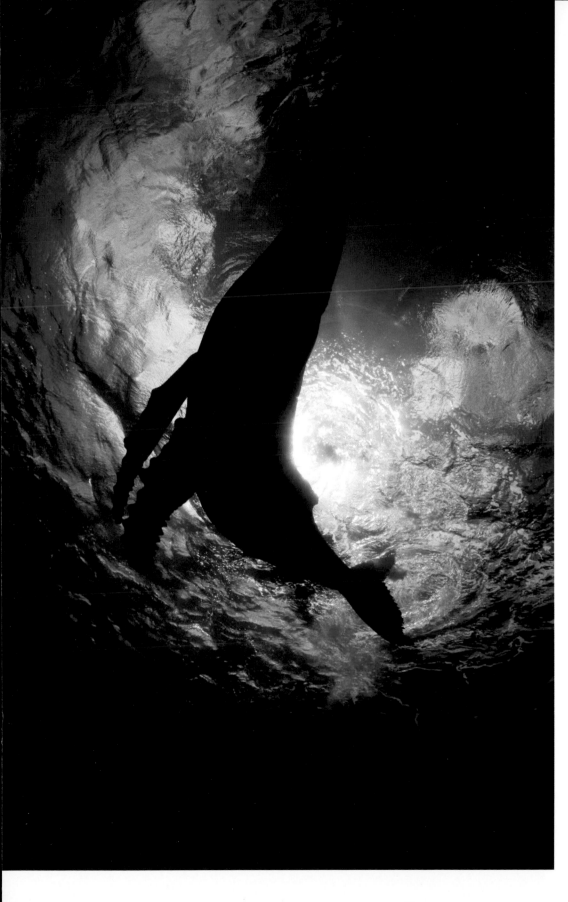

THREATENED SPECIES
Shadow of a species
Scott Portelli, New South Wales

This photograph has a strong emotional connection that represents the devastation brought upon these amazing creatures in the past century. With whales still being hunted today, it could only be a matter of time before these creatures are just a distant memory or shadow of what they used to be.

Tonga, South Pacific

■ Canon 5D MkII, 15mm fisheye lens, 1/250, f14, ISO 200

Status: The Humpback Whale (*Megaptera novaeangliae*) is listed as Vulnerable.

BLACK AND WHITE

A subject must be chosen that would qualify for any of the first six sections.
This section includes all monochrome photography, for example sepia-toned
and infrared photographs.

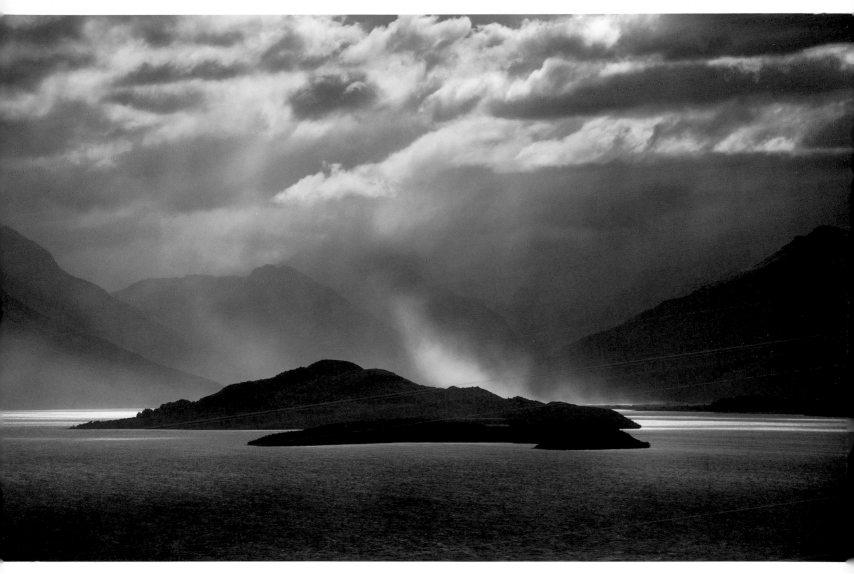

BLACK AND WHITE – WINNER
Nor'wester
Mike Hollman, New Zealand

This was shot from a high viewpoint called Bennet's Bluff, looking along Lake Wakatipu. There was a very strong north-westerly wind blowing, creating a lot of dust at the head of the lake. Combined with the contrasting light, I thought this would make an interesting black and white image.

Lake Wakatipu towards Pigeon Island, Otago, New Zealand

■ Nikon D700, Nikkor 70–200mm f/2.8 VR lens, 1/4000, f4.5

'Beautifully composed, with skilfully handled tones, particularly in the blacks. This image suits the mood of the location. A worthy winner in a very strong section.'
JUDGES' COMMENT

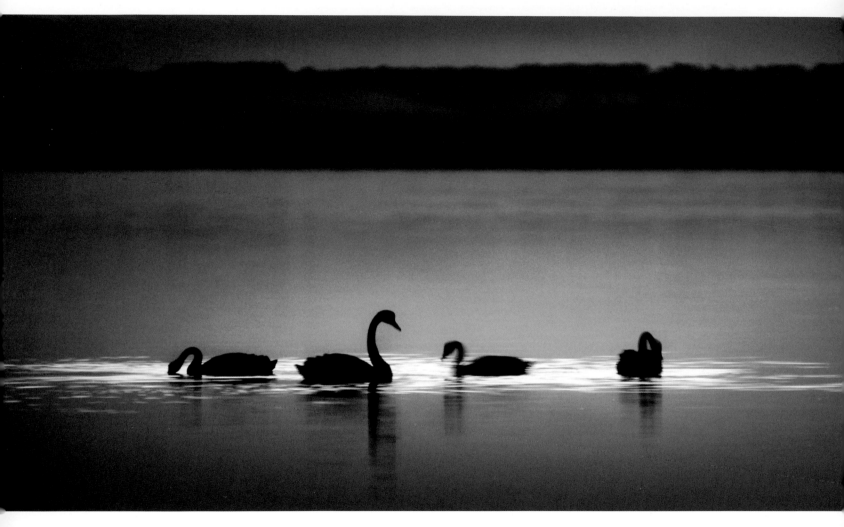

BLACK AND WHITE – RUNNER-UP

Moonlight swanata

Sean McGowan, South Australia

Beneath the rising full moon, the swan family settled down for the night, their ripples creating a shimmering pool of moonlight around them. Manual exposure was used after spot metering on the mid-frame water to maintain the broad tonal range. Burning and vignetting was achieved in post-production using an adjustment layer blended in multiply mode and painted through a mask.

Nepean Bay, Kangaroo Island, South Australia

■ Nikon D300, Nikon 80–200mm lens at 200mm, 1 second, f2.8, ISO 200, tripod, cable release

BLACK AND WHITE

Backlit dragonfly

Dan Giselsson, Tasmania

I love the way in which the delicate tracery of a dragonfly's wings can gather and reflect the morning or evening light. However, with this image I have used the sunset to highlight the dragonfly in a different manner.

Charleville, Queensland

■ Nikon D200, Sigma 150mm f/2.8 macro lens, 1/8000, f2.8, ISO 200

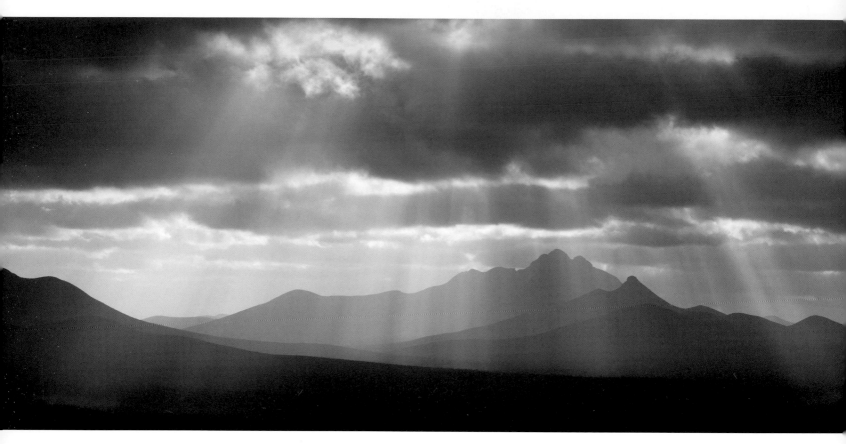

BLACK AND WHITE

Breakthrough

Andrew Halsall, Western Australia

I had planned to shoot some images from the top of the Bluff, but low cloud had covered the top of the mountains and it was a white-out. We had hiked part of the way up, and as we came down the sun's rays began to break through the clouds and made the day worthwhile.

Stirling Range National Park, Great Southern, Western Australia

■ Canon 1Ds MkIII, Canon 24–105mm f/4L lens at 93mm, 1/80, f14, SS, Gitzo tripod, polarising filter

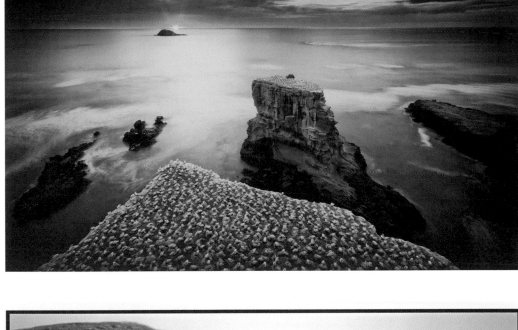

BLACK AND WHITE

Muriwai gannet colony

Chris Gin, New Zealand

I love photographing Auckland's rugged west coast beaches, and this viewpoint is one of my favourites due to the gannet colony. About 1200 pairs of gannets nest here from August to March each year and transform this beach into something so amazing, yet natural.

Muriwai beach, Auckland, New Zealand

■ Canon 40D, Sigma 10–20mm lens, Hitech 0.9 GND filter, 13 seconds, f18, ISO 100

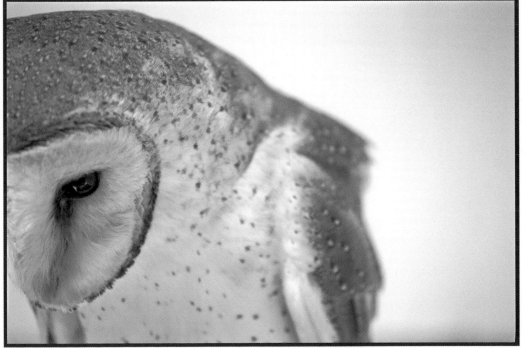

BLACK AND WHITE

Barn Owl – quiet reflection

Danielle Briggs, Victoria

This image of Tin Tin the Barn Owl was captured at the Full Flight Birds of Prey Conservation Centre, a licensed education, breeding and tourist facility designed to educate and inform the public about Australia's unique raptors.

Flemington, Victoria

■ Canon AE1, Canon 100mm lens, 1/60, f8, Kodak Tmax 400

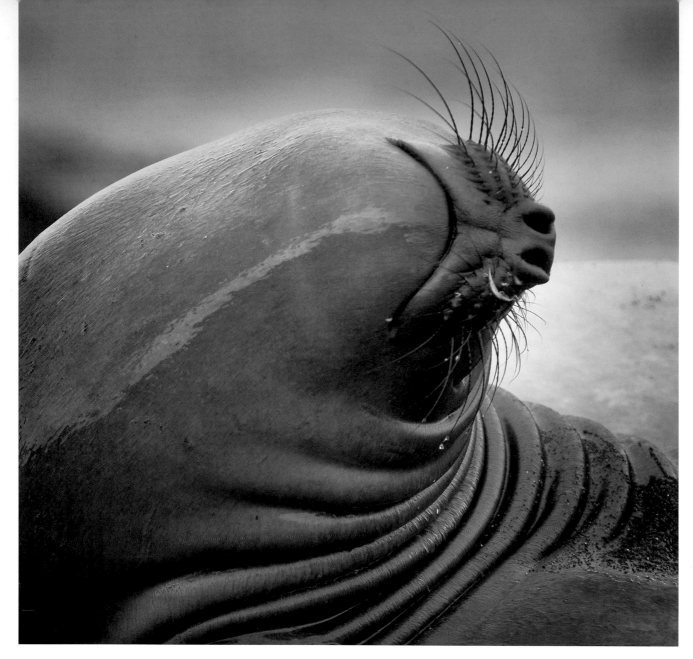

BLACK AND WHITE

What awaits?

Graham Morgan, New South Wales

A recently weaned Elephant Seal pup, gazing out to sea at Gold Harbour. Abandoned by their mothers, the pups huddle together and ready themselves for their first foray into the Southern Ocean.

Gold Harbour, South Georgia

■ Canon 1D MkIV, Canon 400mm DO IS lens, 1/320, f5.6, ISO 100

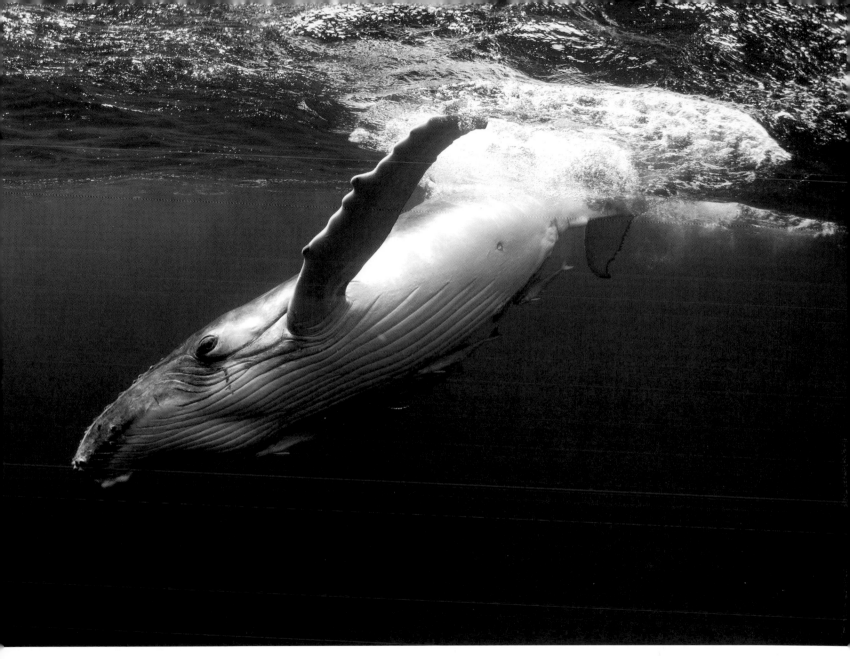

BLACK AND WHITE

Playful

Scott Portelli, New South Wales

Humpback Whale calves are often quite curious. With each and every pass this calf became more confident and playful. It would roll around and slap its tail on the surface, showing me how clever it was. It is a unique privilege to be in the water with a Humpback Whale – encounters like this are rare.

Tonga, South Pacific

■ Canon 5D MkII, 15mm fisheye lens, 1/200, f8, ISO 320

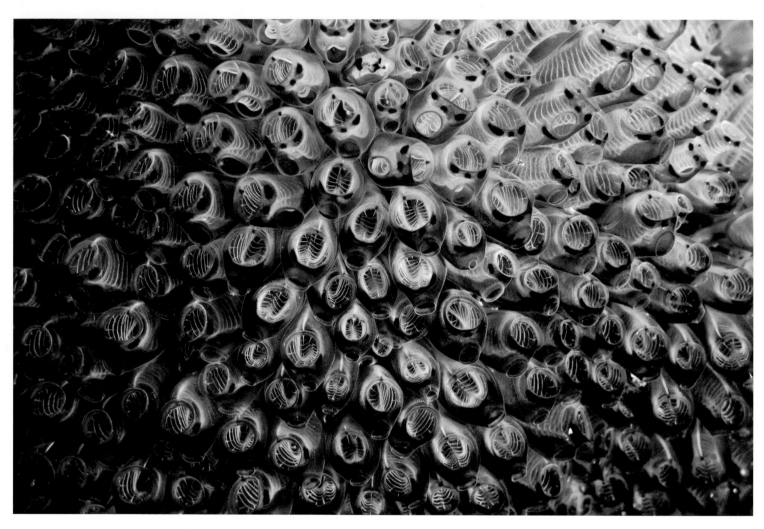

BLACK AND WHITE

Ascidians

Wayne Osborn, Western Australia

The delicate and translucent flask-shaped bodies of colonial ascidians appear as a wall of hungry mouths. These filter feeders cluster together to garner nourishment from the surrounding water.

Busselton Jetty, Western Australia

■ Nikon D2X, 105mm Nikon AF macro lens, 1/200, f11, ISO 250, Nexus underwater housing with flat port, twin strobes

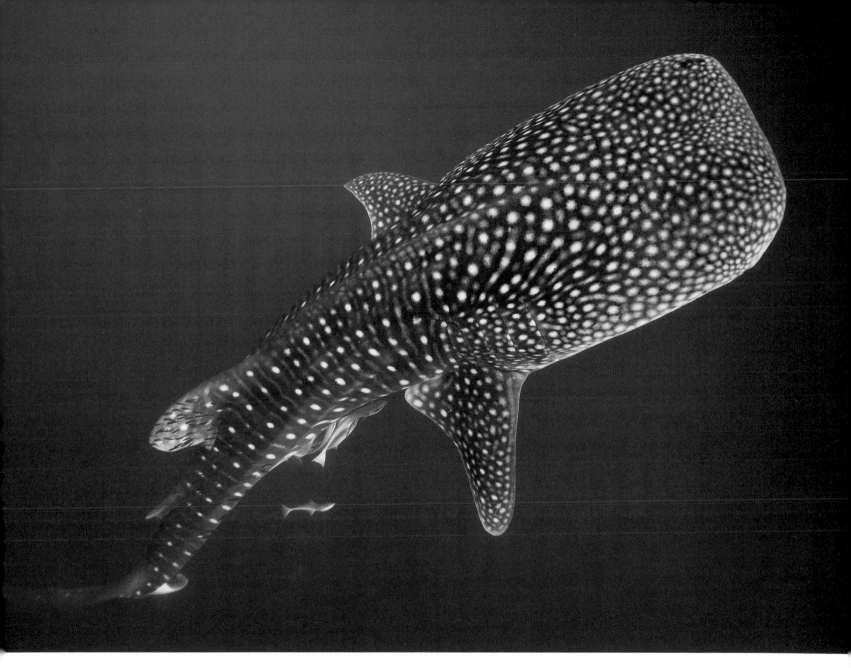

BLACK AND WHITE

Whale Shark surfacing

Wayne Osborn, Western Australia

We know precious little about these solitary leviathans that roam our coastline. This image was taken during a tagging expedition by the Australian Institute of Marine Science. Scientists were tagging the Whale Sharks in order to gain more knowledge of their behaviour and migration patterns. I was a volunteer taking photographs for the expedition.

Ningaloo Reef, Western Australia

■ Canon 5D MkII, Canon AF 16–35mm f2.8L lens at 16mm, 1/250, f3.5, ISO 400, Nexus underwater housing with dome port, natural light

INTERPRETIVE

A subject or subjects must be chosen that would qualify for any of the other sections. This section is designed for those photographers who wish to experiment graphically with their images.

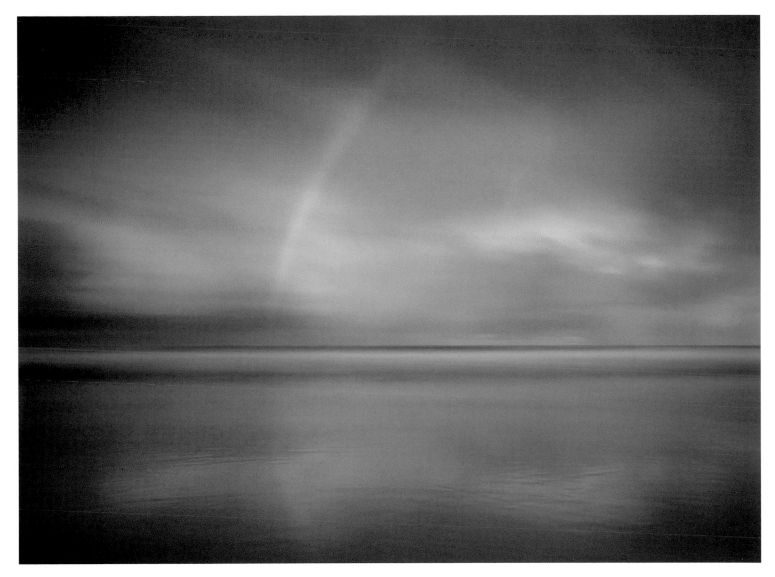

INTERPRETIVE – WINNER

Rainbow sunrise, South Cape Bay

Wolfgang Glowacki, Tasmania

A 3-minute exposure added a beautiful softness to what is one of the wildest beaches in Tasmania.
The rainbow was a bonus.

South Cape Bay, Tasmania

■ Canon 1DS MkIII, 24mm lens, 3 minutes, f11

*'A positively ethereal image that has
been created rather than captured.
It is uplifting and fortuitous.'*
JUDGES' COMMENT

Me & my shadow

Paul Huntley, New South Wales

Enjoying a quiet lunch under the shade of a tented safari-style roof in Port Douglas, I had no sooner noticed the interesting abstract patterns created by the fallen leaves when a Cattle Egret landed and started searching for its own lunch up there. Its shadowy movements made for a memorable and unique image.

Port Douglas, Queensland

■ Canon 1Ds MkII, EF 300 f/4L IS lens handheld, 1/640, f4, ISO 400

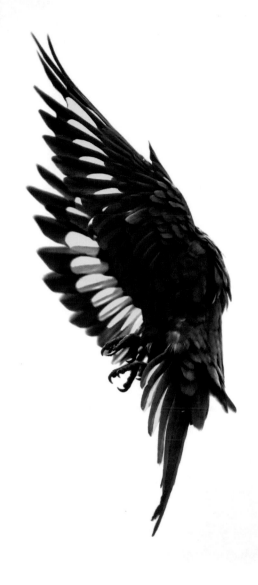

INTERPRETIVE

Rainbow Lorikeet in flight

Michael Gallagher, United Kingdom

As a boy I would marvel at all the Rainbow Lorikeets that congregated in our backyard every afternoon. I moved away from home a long time ago, but whenever I visit mum I spend many afternoons in the backyard trying to capture that one special shot of these remarkable birds.

Mum's backyard, Toowoomba, Queensland

■ Canon 50D, 300mm f/2.8L IS lens handheld, 1/5000, f2.8, ISO 400

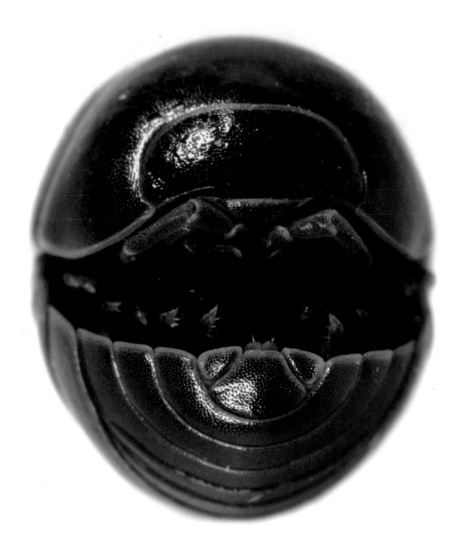

INTERPRETIVE

Nature's Pacman – a slater's defence

Alan Kwok, New South Wales

Everyone knows a slater – that odd 'land crustacean' from the garden that you poked and prodded when you were a kid, watching in amusement as it curled up into a tiny armoured ball. Decades later, as I photographed this critter, I still watched in amusement as it did its thing. Some things don't change!

Sydney, New South Wales

■ Canon 5D, MP-E 65mm 1–5x lens, 1/200, f4.5, flash

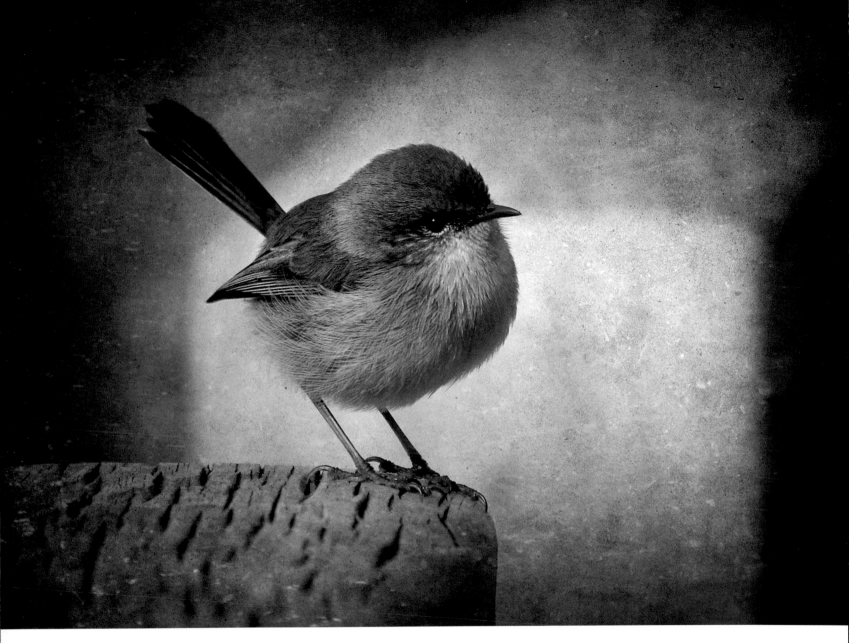

INTERPRETIVE

Misty blue

Barb Leopold, South Australia

I photographed this male Superb Fairy-wren at Cleland Wildlife Park in the Adelaide Hills, which is a great natural habitat for these small native birds. I have added textures in Photoshop to create a fantasy image of this alert and beautiful Australian bird.

Cleland Wildlife Park, South Australia

■ Canon 40D, Canon 70–300 f/4–5.6L IS lens, 1/400, f7.1, ISO 500

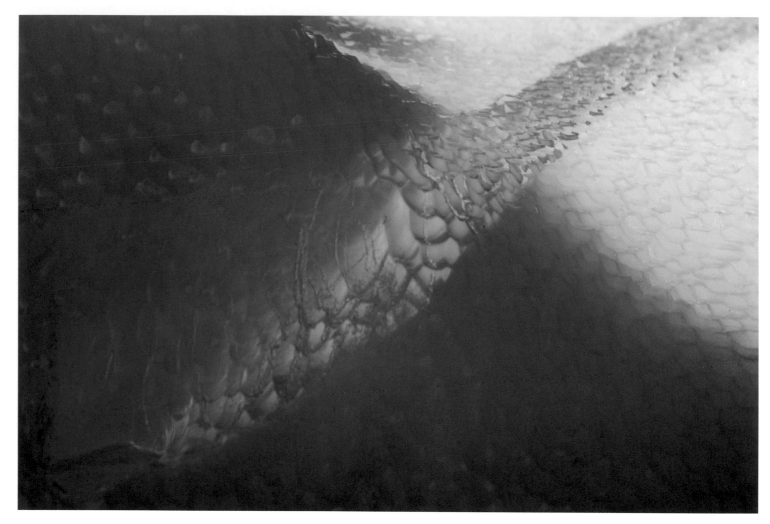

INTERPRETIVE

Ice diamonds

Denis Glennon AO, Western Australia

This image was taken from a Zodiac in Antarctica. The apparent fissure in the iceberg and the sun produced the stunning effect above and below the waterline, giving a small portion of ice the diamond-like blue hues.

Antarctica

■ Canon 1D MkIV, Canon 70–300mm f/4.5–5.6L IS lens, 1/1600, f5, ISO 200

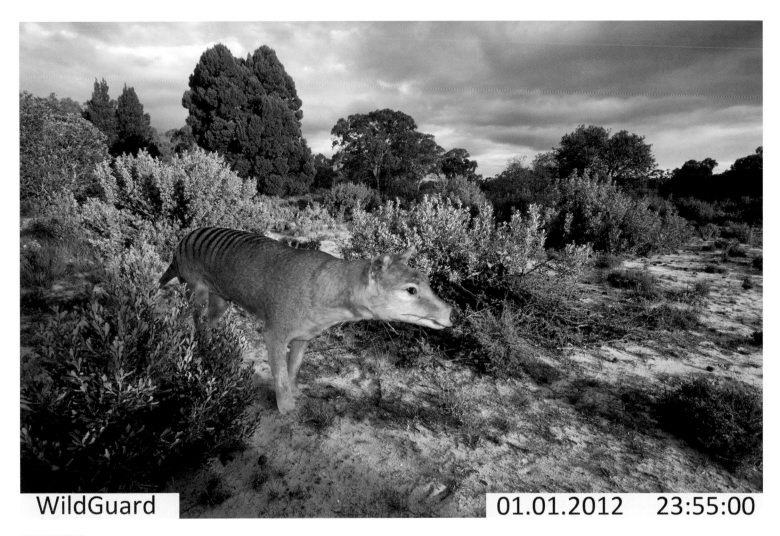

WildGuard 01.01.2012 23:55:00

INTERPRETIVE

Return of the thylacine

Erwin van Maanen, The Netherlands

In 1936 the last thylacine died at Hobart Zoo, but its legacy still haunts many. This image serves to expose the plight of the other tiger and other large carnivores that may soon become extinct in the wild. Will we stand idle again this time? Perhaps a glimmer of hope.

Little Desert National Park (Victoria) and mounted thylacine or Tasmanian Tiger (*Thylacinus cynocephalus*) from the South Australian Museum

■ Landscape: Canon 5D MkII, Canon 17–40mm f/4L USM lens, 1/125s, f8, ISO 200
Thylacine: Canon Powershot G7, 1/60, f2.8, ISO 200

INTERPRETIVE

Foam patterns in tannin water

Rob Blakers, Tasmania

Foam collects in an eddy in a small rivulet on an alpine plateau. Through gaps in the foam the rock and pebbles at the bottom of the pool are visible, naturally coloured by the tannin water.

West Coast Range, Tasmania

■ Canon 5D MkII, Canon TS-E 24mm f3.5L lens, handheld, 1/60th, f11, forward tilt

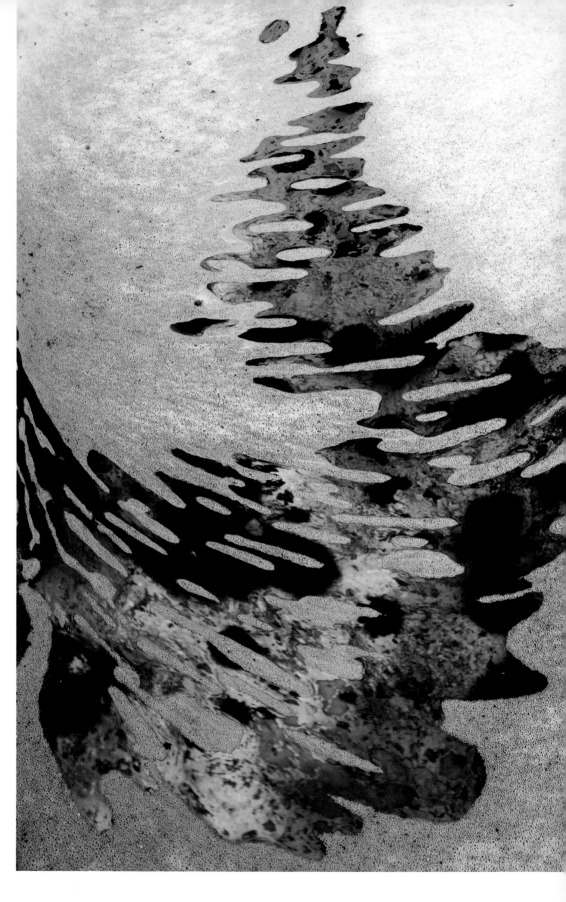

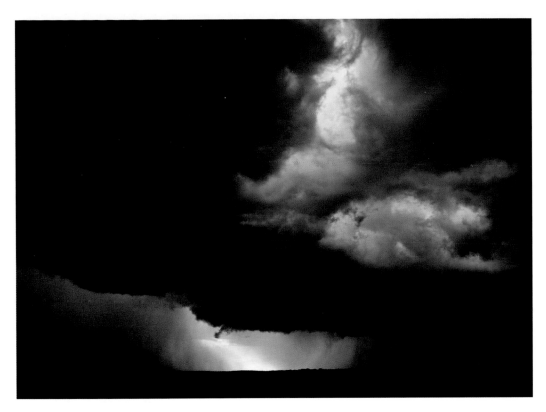

INTERPRETIVE

A force of nature

Sheryn Ellis, Queensland

We had travelled 350 km from Lyndhurst up the Strzelecki Track before this storm front engulfed us. As the first drops of rain fell, our vehicle became a 'puck', sliding on the 'Strzelecki ice rink'. While my husband navigated the road, I hung out the window capturing frame after frame of nature's most powerful force.

North of Lyndhurst along the Strzelecki Track, South Australia

■ Canon 5D MkII, Canon 24–70mm f/2.8L lens, RAW image, 1/50, f5, ISO 200

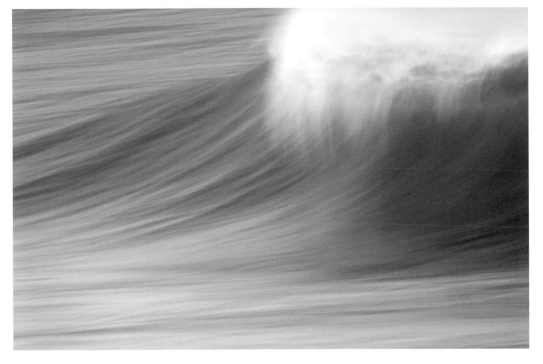

INTERPRETIVE

Wavescape – 'Poised'

Steve Young, New South Wales

I watch the daily moods of the ocean. Some days there's anger – and other days just an offer to sit and take notice. Each wave is unique. 'Poised' was photographed on a day when nature's energy was quite powerful, yet I saw an undeniably gentle beauty as well.

Bare Bluff, Sandy Beach, New South Wales

■ Canon 5D, Canon 70–200mm lens, 2x zoom at 400mm, 0.6 seconds, f64, ISO 100

OUR IMPACT

The image must depict human impact on the natural environment, be it terrestrial, marine or atmospheric. This impact may be negative or positive. The choice of subjects is broad, including any that would qualify for the other sections or extending beyond these to subjects relating to pollution and climate change.

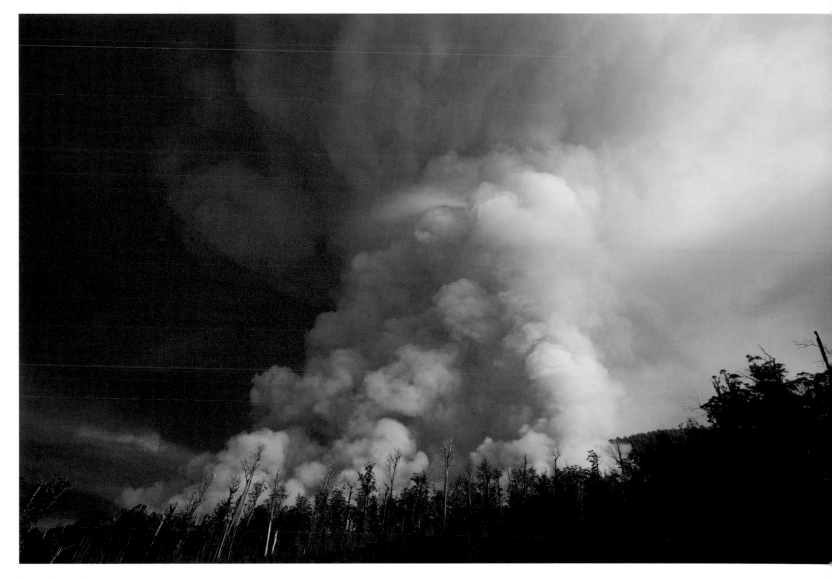

OUR IMPACT – WINNER

Forestry burn

Rob Blakers, Tasmania

Smoke clouds rise above a logging coupe that has been lit by napalm-like incendiaries dropped from a helicopter. Such 'regeneration burns' emit massive amounts of carbon pollution, on average 700 tonnes/hectare. Such logging and burning devastates the natural forest and its wildlife.

Weld Valley, southern Tasmania

■ Canon 5D, Canon 16–35mm f2.8L lens, 1/60, f11, ASA 100, tripod

'This image has an apocalyptic mood, showing the enormous scale of forest fires, even in the relatively small scale of this controlled burn.'
JUDGES' COMMENT

OUR IMPACT – RUNNER-UP

Any port in a storm

Alan Kwok, New South Wales

So much is made of our negative impact on wildlife that we sometimes fail to appreciate the resilience and adaptability of animals and plants. Even in the suburbs some animals can find a port in our concrete storm, as shown here by Peron's Tree Frog (*Litoria peronii*).

Castle Hill, New South Wales

■ Canon 5D MkII, Tamron 90mm lens, 5 seconds, f8

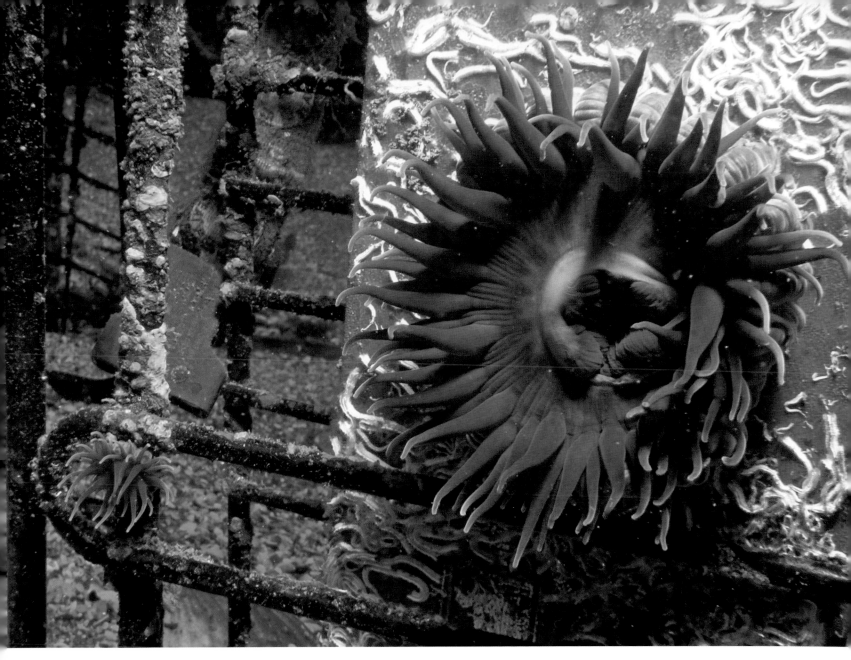

OUR IMPACT
A novel habitat
Keith Martin-Smith, Tasmania

At my favourite dive site this abandoned shopping trolley finds a new use as a habitat for marine life. The small Waratah Anemone is probably a clone of the larger individual, grown within its body cavity and ejected through its mouth.

Blackman's Bay, Tasmania

■ Olympus SP550UZ, underwater housing, Inon D2000 strobe, FL 4.7mm, 1/30, f5.6, ISO 50, auto white balance

OUR IMPACT

Iron rich – selling the Pilbara to China

Alice Gillam, Western Australia

Iron ore mining is booming in the Pilbara. New and all-weather roads have opened up the region for mining; there is plenty of iron ore being discovered. Underfunded, undermanaged and barely noticed is the increasingly threatened biodiversity of the Pilbara. Good governance holds the key; the party is just beginning.

Pilbara, along the road just north of Millstream Chichester National Park, Western Australia

■ Canon 5DII, 24–70mm f2.8L lens at 40mm, polariser, tripod

OUR IMPACT

Leatherback hatchling footprint

Anthony Plummer, Victoria

In the past, human presence would have spelled doom for a Leatherback Turtle. But now, the only footprints on this beach are those of former hunters turned conservationists, who are working to wrest this species from the brink of extinction by protecting nests and guarding hatchlings on their perilous journey to the ocean.

Queru Beach, Tetepare Island, Western Province, Solomon Islands

■ Nikon D200, AF Micro Nikkor 60mm f/2.8D lens, 1/160, f3.2, ISO 100

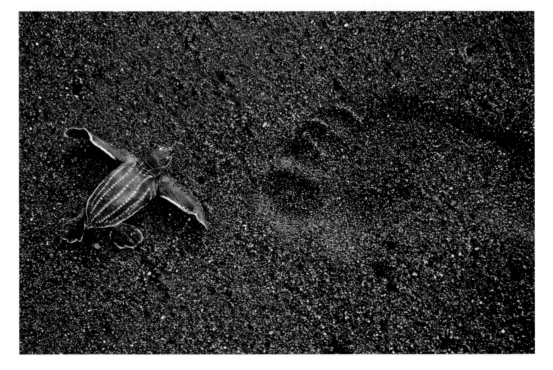

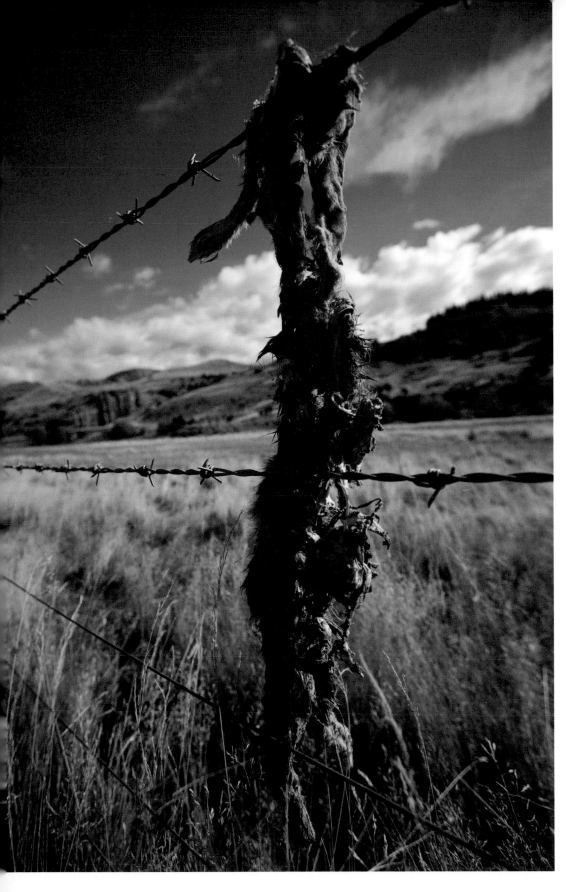

OUR IMPACT
Rabbit-proof fence
Kah Kit Yoong, Victoria

While photographing the autumn foliage around Wanaka and Cardrona, I came across this decayed carcass with its mouth caught around a barbed wire fence. Introduced animals, once the whim of human folly, may eventually become pests. In stark contrast to the picturesque scenery around me, is this wiry grave justified?

Wanaka, New Zealand

■ Canon 5D MkII, Canon 16–35mm f/2.8L lens, 1/1000, f5, ISO 100

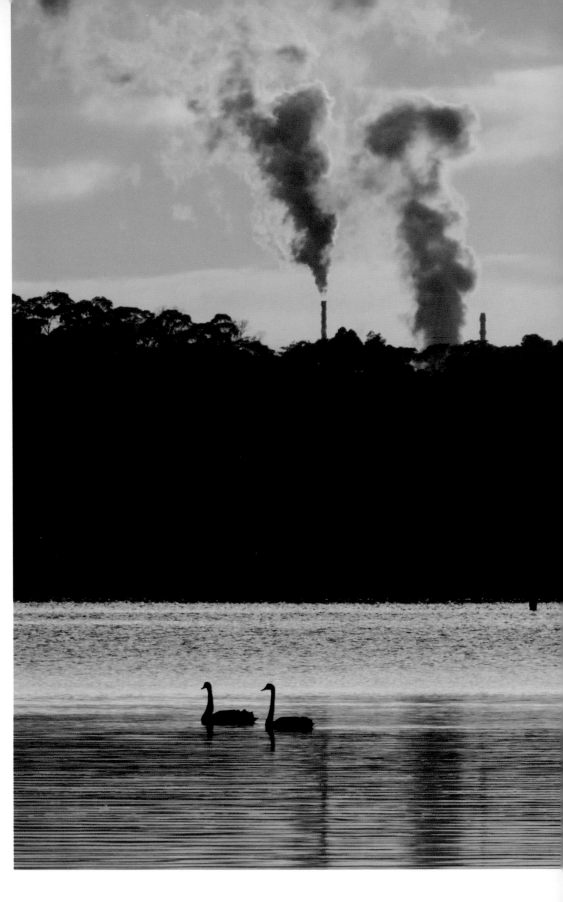

OUR IMPACT
Beauty and the beast
Michele Sawyer, South Australia

I had observed the Black Swans from Beauty Point the day before, and my intention was to photograph them at sunrise. But what dominated the scene that morning was a thick black plume billowing from the aluminium smelter on the opposite side of the river.

Beauty Point, Tamar River, Tasmania

■ Canon 1D MkIII, Canon 100–400mm f4–5.6L lens at 250mm, 1/250, f16, ISO 400

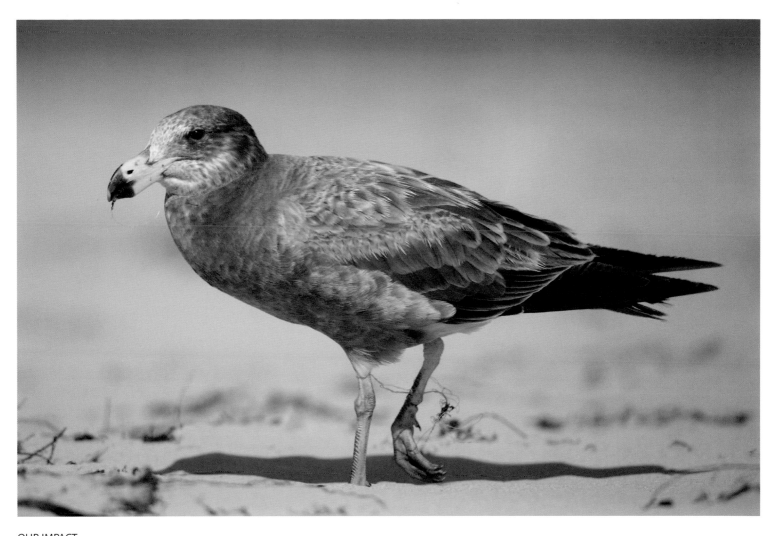

OUR IMPACT

Troubled Pacific Gull

Paul Randall, Victoria

It seems that this species is particularly prone to injury from fishing hooks and line because of its tendency to hang around popular fishing haunts like piers and boat ramps.

Barwon Heads, Victoria

■ Canon 5D, 600mm f/4L (non-IS) lens, 1/8000, f5, ISO 400

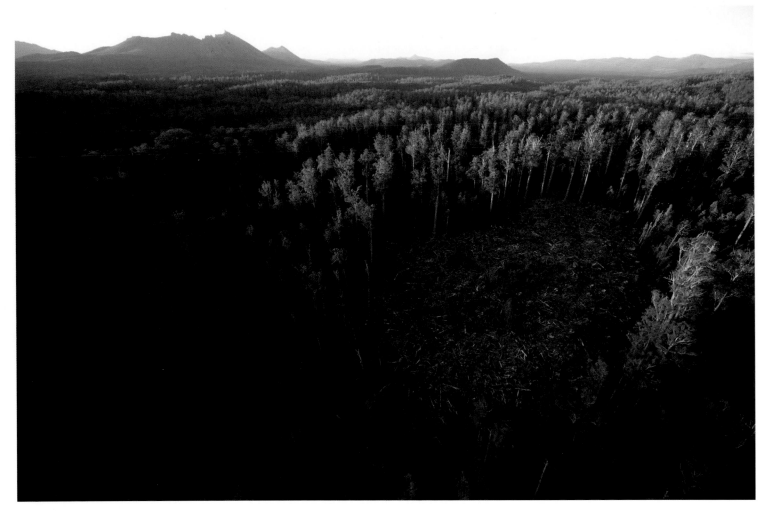

OUR IMPACT
Old-growth wilderness logging
Rob Blakers, Tasmania

Surrounded on three sides by the Western Tasmania World Heritage Wilderness, the magnificent tall forests of the Upper Florentine Valley are zoned for clearfell logging. The subject of fierce and long-standing protests, this coupe was logged with police protection in May 2009. The fate of other forests in the valley remains in the balance.

Upper Florentine Valley, south-west Tasmania

■ Canon 5D MkII, Canon 16–35mm f2.8L lens, 1/200, f5.6, ASA 400

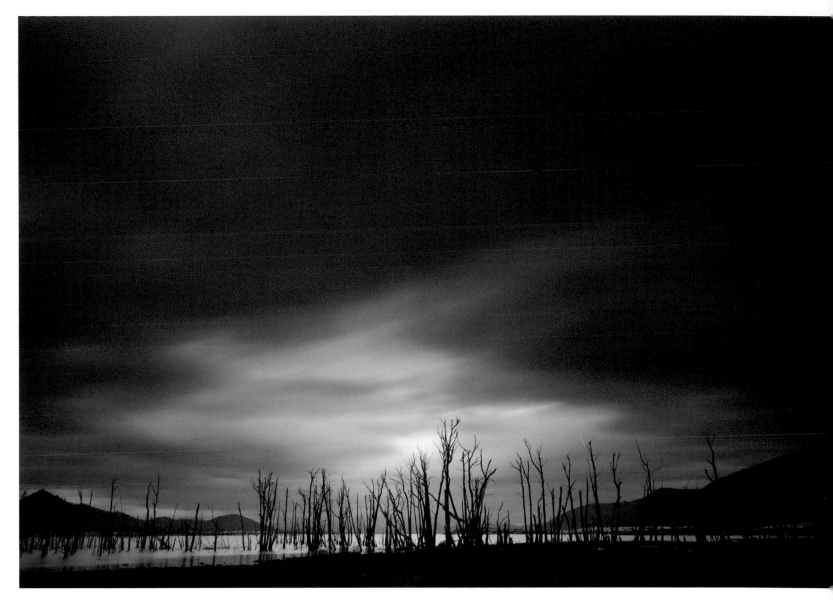

OUR IMPACT

Sorry – Lake Gordon, south-west Tasmania

Wolfgang Glowacki, Tasmania

In the early 1970s the Hydro-Electric Commission constructed a dam on the Gordon River. It was the largest and most controversial hydroelectric power scheme in Tasmania, flooding more than 272 km^2 of pristine forest including stands of Huon Pine up to 2000 years old.

Gordon River, Tasmania

■ Canon 1DS MkII, 24mm lens, 1 minute, f20

JUNIOR

The entrant must be under 18 years of age at the date of the close of entries.
Entries must otherwise qualify for any of the other sections.

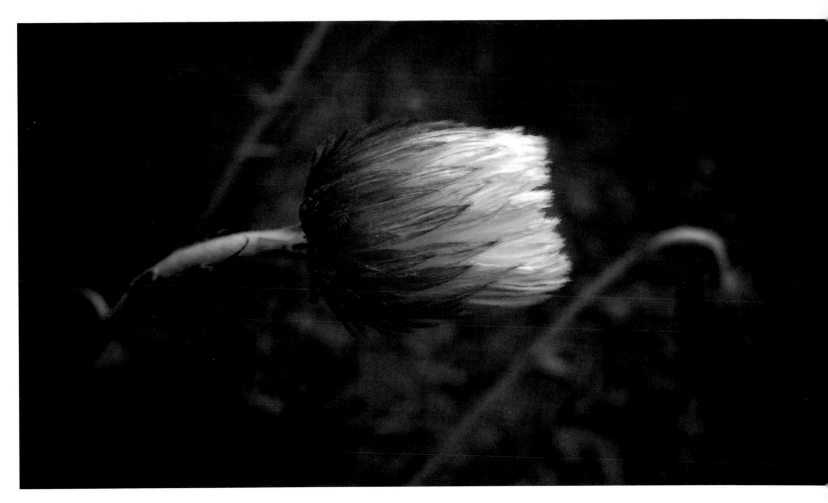

JUNIOR – WINNER

Wild and everlasting Paper Daisy

Paris Williams, South Australia, age 11

Silky brown petals layering over long, feathery petticoats of soft white points. Nefertiti herself was not more finely adorned than this tiny flower.

Bradbury, South Australia

■ Canon Powershot TX1, 6.5mm (39mm equivalent to 35mm film), 1/200, f5, ISO 80

'Gentle and mature, this image is worthy of contemplation. It grows on you – stop and look at it for a while.'
JUDGES' COMMENT

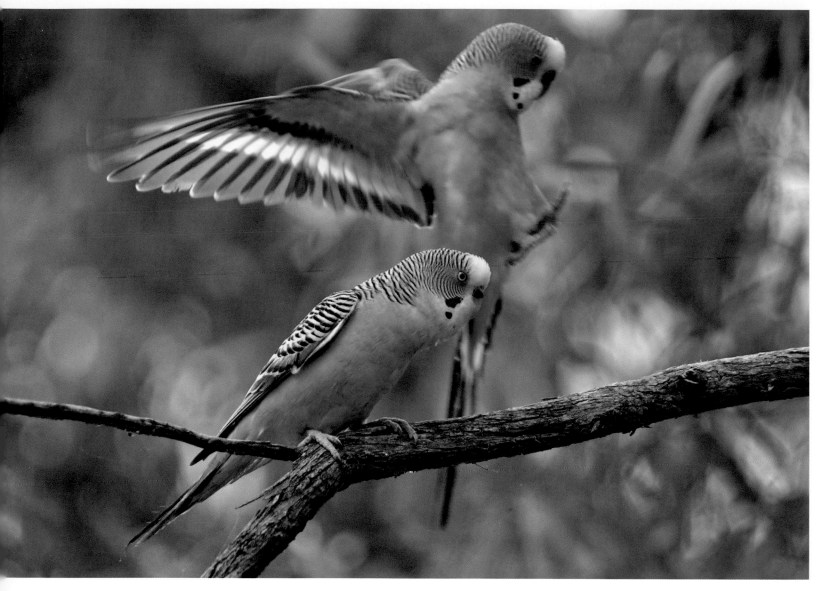

JUNIOR – RUNNER-UP

Landing

Joshua Bergmark, New South Wales, age 15

In October 2010 at Kilcowera Station, the outback was flourishing. We were camped on the banks of the overflowing Cardenyabba Lagoon, surrounded by Budgerigars nesting in every available tree hollow. This scene was captured late one afternoon as the birds were returning to their hollows for the night.

Kilcowera Station, south-western Queensland

■ Nikon D5000, 300mm lens, 1/800, f6.3

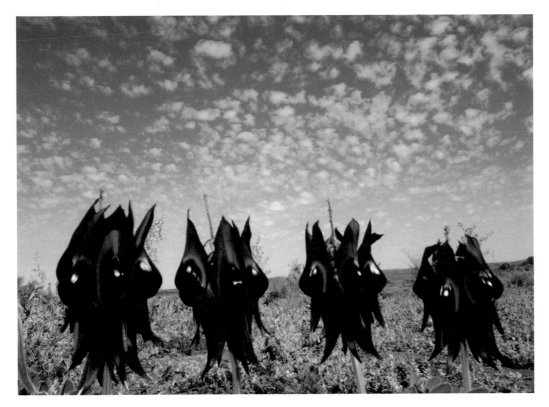

JUNIOR

Sturt Desert Peas

Emily Ryan, New South Wales, age 13

This photograph was taken on the outskirts of Broken Hill, while the Sturt Desert Pea flower was in late bloom. It was taken from ground level, facing the sky, so as to gain some perspective on the looming desert in contrast with the stunning little flowers.

Broken Hill, New South Wales.

■ Fujifilm Finepix E500

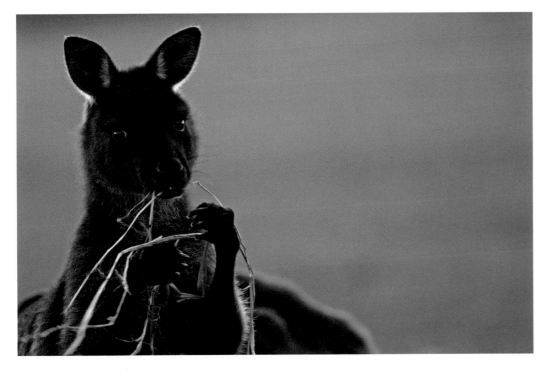

JUNIOR

Western Grey Kangaroo (*Macropus fuliginosus*) feeding

Brieuc Graillot Denaix, France, age 16

During holidays in Australia, I spent a week on Kangaroo Island with my family. Six months earlier, lightning caused serious fires, destroying the forest in Flinders Chase National Park. At the end of one afternoon, we found a group of Western Grey Kangaroos eating some straw brought by a ranger.

Kangaroo Island, South Australia

■ Canon 40D, 300mm f/4L lens, 1/60, f4, 400 ISO

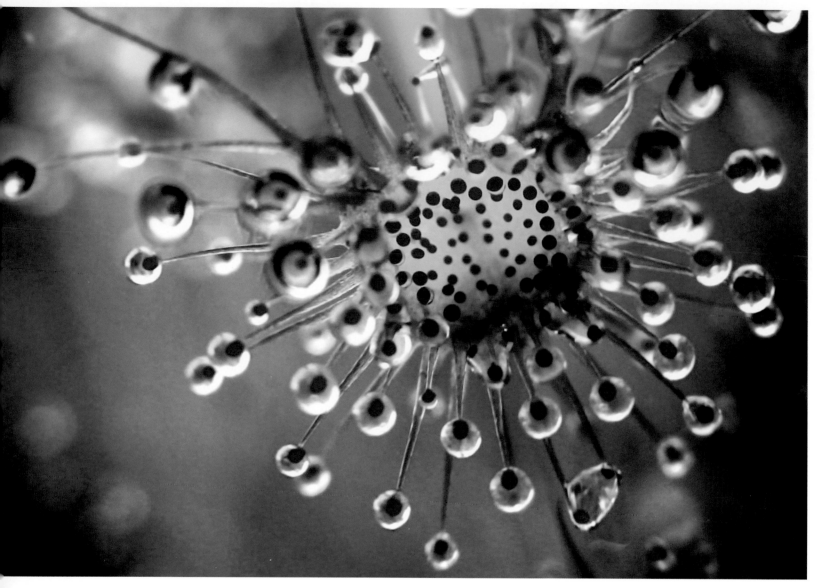

JUNIOR

Dewey monster (*Drosera peltata* ssp. *auriculata*)

Paris Williams, South Australia, age 11

This remarkable leaf calls to mind an alien from another planet, with fingers reaching out beyond the page from its world into ours. The amazing thing is that its world is right here at our feet.

Bradbury, South Australia

■ Canon Powershot TX1, 6.5mm (39mm equivalent to 35mm film), 1/60, f4, ISO 80

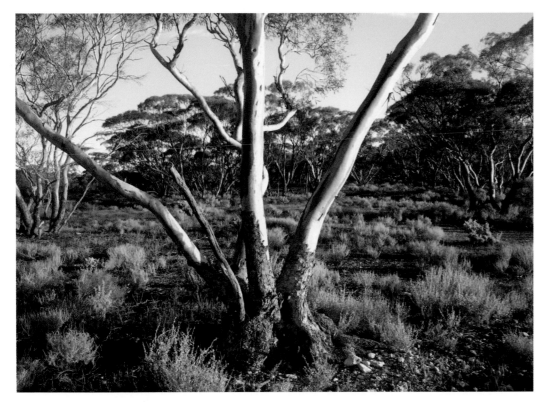

JUNIOR

Mallee colours

Simon Fahey-Sparks, South Australia, age 15

The vast beauty of the mallee is challenging to capture in a single shot. I came across this quietly harmonious scene while I was cycling along a mallee track one morning.

Brenda Park Station, Morgan, South Australia

■ Panasonic Lumix DMC-FS4, FL 5.9mm, 1/250, f2.9, ISO 80

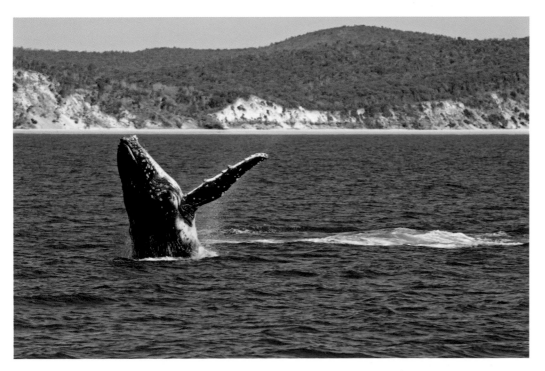

JUNIOR

Humpback Whale (Megaptera novaeangliae)

Maud Graillot Denaix, France, age 13

During holidays in Australia, we went to see whales in Hervey Bay. On the second day we were lucky enough to see one jumping! At that moment, my father was putting away his camera and lenses, so only my mother and I were ready to shoot!

Hervey Bay, Queensland

■ Canon 40D, 70–200mm f/4L lens, 1/1000, f6.3, ISO 200

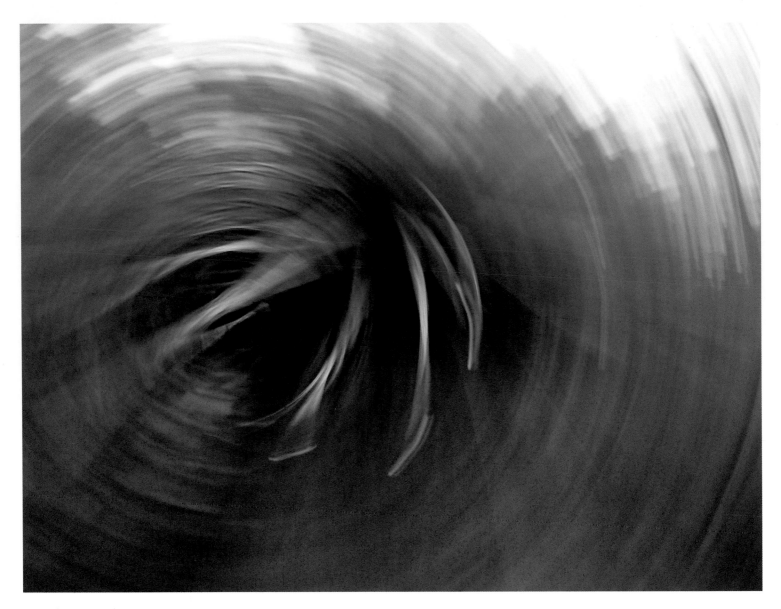

JUNIOR

Grass tree spin

Simon Fahey-Sparks, South Australia, age 15

I took this photograph while bushwalking on a cold morning in Cleland Conservation Park. I achieved the spinning effect by rotating the camera quickly with a slow shutter speed. My intention was to accentuate the drops of dew on the thin grass tree leaves.

Cleland Conservation Park, South Australia

■ Panasonic Lumix DMC-FS4, FL 5.5mm, 1/13, f2.8, ISO 100

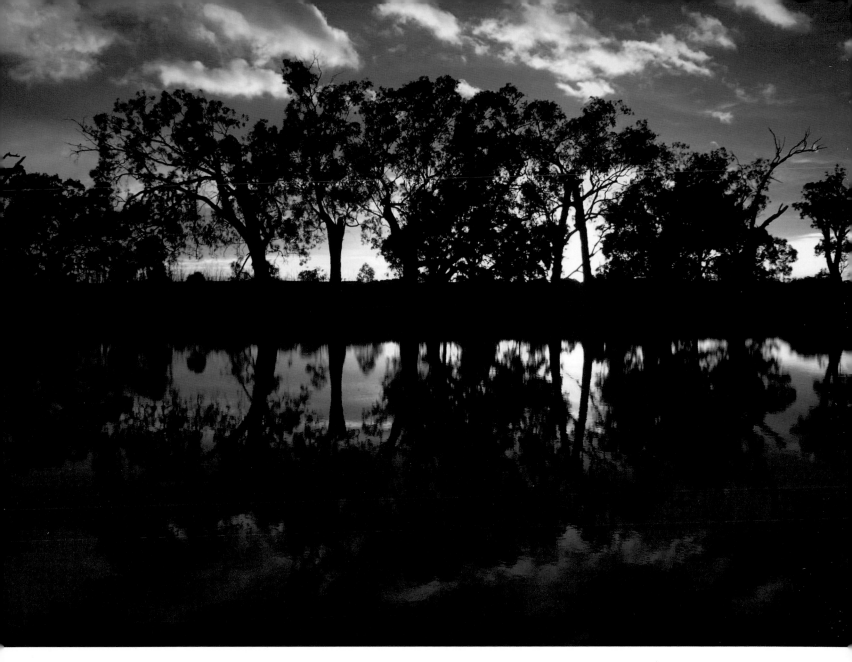

JUNIOR

Murray dawn

Simon Fahey-Sparks, South Australia, age 15

I had to wade through waist-deep water and a swarm of mosquitoes to reach a partially flooded pontoon, which was my vantage point for the photograph. After several minutes of standing in the cold, I saw the sun finally rise, vividly lighting up the passing clouds.

Scotts Creek Outdoor Centre, Morgan, South Australia

■ Panasonic Lumix DMC-FS4, FL 5.5mm, 1/125, f2.8, ISO 80

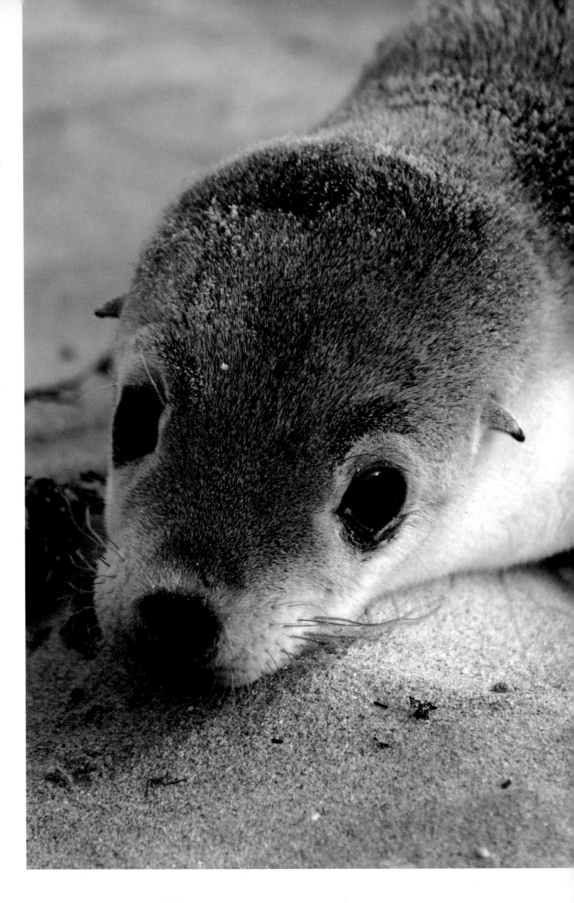

JUNIOR

Australian Sea-lion pup

Tessa Manning, South Australia, age 13

This image was one of the first that I took with my new camera. It was taken on a pre-sunset tour at Seal Bay on Christmas Eve. This little pup was waiting for its mum to come ashore. It came within a metre of our group and it was a great experience.

Seal Bay, Kangaroo Island, South Australia

■ Canon 20D, 300mm lens, 1/2500, f5.6, ISO 800